WAKING UP
to the
GOODNESS
OF GOD

40 DAYS TOWARD HEALING AND WHOLENESS

SUSIE LARSON

W PUBLISHING GROUP

AN IMPRINT OF THOMAS NELSON

Published in Nashville, Tennessee, by W Publishing, an imprint of Thomas Nelson.

Author represented by the Steve Laube Agency.

Thomas Nelson titles may be purchased in bulk for educational, business, fundraising, or sales promotional use. For information, please email SpecialMarkets@ThomasNelson.com.

ISBN 978-0-7852-9473-3 (audiobook)
ISBN 978-0-7852-9472-6 (ePub)
ISBN 978-0-7852-9471-9 (Hardcover)

Library of Congress Control Number: 2023941246

Printed in the United States of America

23 24 25 26 27 LBC 5 4 3 2 1

To my friends,
for daring me to look for and find
God's goodness in and all around me.
I'm forever grateful.
Thank you.

And to Kev,
who displays God's patience and kindness
every single day.
I love you.

contents

introduction

Bracing for Impact

I've lived much of my adult life bracing for impact. I love Jesus. I worship Him, enjoy Him, and spend hours in His Word. How is it possible to pursue Jesus earnestly yet simultaneously live with elbows locked? Though I loved my times with Jesus, I had developed a posture of self-protection, just waiting for the next storm to hit. I welcomed God's presence, but I didn't always trust Him to protect me. Perhaps you've heard my story and know I've battled Lyme disease for more than three decades. Because of the cyclical nature of the illness, I never know when a surge of symptoms is about to blindside me and knock me off my feet.

Though God has allowed me to do much for Him amid my physical weakness, for years I often felt like an outsider. I noticed that others enjoyed life in a way I couldn't relate to—in a way I longed to. I had moments of reprieve (and I jumped for joy in gratitude), but I often felt crummy.

Many days, I found a way to be faithful and grateful and to stand on God's Word when it seemed no breakthrough was in sight. And many, many times, God met me with His peace, compassion, and comfort. Oh, how I love Him.

But to be honest, deep in the recesses of my soul, unbeknownst to me,

lived a certain distrust of and disappointment in God. At first, I didn't identify it as such. I didn't connect bracing for impact with distrusting God. I just thought it was the natural result of living with an unpredictable disease for many years. Then, one day, God showed me my heart in a way I could not deny. I realized I was disappointed in Him. Hurt by Him. Not enough to walk away from Him (where would I go?) but enough to rob me of the gift of expectancy.

Did God shun me? No. He mobilized a group of women to march with me to freedom, wholeness, and healing. My friend Maria said something I'll never forget: "Remember what the psalmist said? *Surely only goodness and mercy follow me. Surely, they do!* If you don't live with a sense of expectancy, wondering what good thing God is up to in and around you, that's a sign that you need healing, truth, and renewed perspective. It's proof that something is out of alignment in your belief system. Theft pulls us out of alignment. It's the truth that sets us free."[1]

I've spent the last couple of years earnestly *cultivating an expectant heart around God's goodness.* And it's changed everything! I'm not the same person I once was. I'm healing from the inside out. I live with a smile on my face. I keep wondering what surprises God has up His sovereign sleeve. Even on difficult days, I trust more in God's ability to bring gladness than the Enemy's intent to bring sadness. God doesn't write the pain into our stories, but He will most certainly redeem it for His glory.

I now know this: God is kinder than we imagine and far more wonderful than we can fathom. He sings over us. He loves us. And He plans good, good things for us. The Enemy steals, but the Father restores. The Enemy traumatizes, but the Father heals.

Every day, we're given the opportunity either to trust God or to accuse Him. Our most repetitive thoughts reinforce either our captivity or freedom. How we think about God directly impacts the quality of our lives.

We bear God's image. We were created by love, for love, and because of love. When our hurts and hardships so deeply skew our perspective that we no longer trust the One who made us and loves us beyond measure, we've lost our way. Thankfully, our Good Shepherd finds us and leads us to healing and wholeness.

> God is kinder than we imagine and far more wonderful than we can fathom.

> The LORD your God is living among you.
>> He is a mighty savior.
> He will take delight in you with gladness.
>> With his love, he will calm all your fears.
>> He will rejoice over you with joyful songs.
> Zephaniah 3:17

Are you ready to experience renewed vitality? Do you believe God cares about the condition of your soul and that He still answers prayer? Are you willing to position yourself on the path of His promises and see what He might do in and through you?

God has designed us fearfully and wonderfully (Psalm 139:14) so we can start on a new, life-giving path today. We can be wholly delivered from lies that are baked in because of sin, hardship, and trauma. Most times,

though, this doesn't happen overnight. It happens one redemptive thought at a time. One brave, faith-filled step at a time.

Scripture highlights the significance of forty days as the typical length for a pilgrimage or spiritual journey toward a more profound dependence and reliance on God (Genesis 7:4; Exodus 34:28; Matthew 4:1–2). That's why I've chosen to include forty devotions here. Yet over the years I've heard so many people suggest that it takes approximately sixty days of consistent practice of a habit, a renewed thought, or a healthy discipline to impact our brain's structure and physiological health.[2]

So there is no need to be restricted to forty days. What if you decided to set out on this journey but gave yourself permission to go slow, to linger over the truths that resonate with you, and to allow those truths to seep deeply into your cells? When we move too quickly, we sometimes skim over important content. I'd rather you take your time as you read these devotions and experience transformational change as you go.

The words we say and the things we pray matter to God and to our health. Where we rest our gaze and how we think about God directly impacts the condition of our souls. God can restore and renew us even when culture swirls around us. The world needs healing, but we can't impart what we don't possess.

This devotional is intended to move you from a posture of bracing for impact to one of holy expectancy.

Join me on a transformative pilgrimage as we explore God's invitation to flourish, heal, and know His peace in a way that changes us forever. Because "a heart at peace gives life to the body" (Proverbs 14:30 NIV).

how to use this book

I'm so grateful to have you on this forty-day journey! Each day's reading is short, and the layout serves a distinct purpose.

Each day's reading opens with a prayer of faith, praying from above your circumstances. I have found that when I beg and plead with God in prayer, I rarely feel better afterward. But when I remind my soul who God is and who I am to Him, I feel strengthened when I pray. The opening prayer is designed to help grow your faith and secure your footing.

Then you'll read a short devotion on that day's topic. I pray every word you read points you upward to God's goodness and to His beautiful intentions toward you.

Each day's closing faith declaration and brain-retrain statement are meant for you to rehearse throughout the day. Some of these faith declarations will feel like food for your soul. Latch on to *those* words. Say them, pray them, and rehearse them until they become a default setting in your brain. It's important to note that these faith declarations are not intended to promote you, your strength, or even your resolve. Apart from Christ, we

have nothing and can accomplish nothing (John 15:5). But in Christ, we possess all the riches of the heavenly realms (Ephesians 1:3).

And since the Enemy of our souls often plants destructive thoughts in the first person, like, *I am an outsider*, I'd say it's time we counter his lies with the truths of who we are in Christ Jesus. Something changes within us when our ears hear our mouths declare what is true: "I am an overcomer! I possess everything I need because Jesus is alive in me!" So be bold, and read your faith declarations out loud. I'm telling you—it'll weaken the Enemy's influence in your life, and it'll strengthen you.

Finally, at the end of each day's reading, you'll notice I've added a couple of extra passages of Scripture to explore if you choose. You'll revisit a few verses more than once. That's on purpose. I've also included some space where you can briefly respond to what God is teaching you and where He is leading you.

I pray that by the end of our forty days together, you will feel springtime in your soul. You will start to see life springing up all around you. And you will begin to surprise yourself with holy expectancy.

You can read these devotions in the morning or at night, whichever time works best for you. The goal is to awaken to God's goodness, come alive at the thought of His kindness, and reengage your faith because you know your God is meticulous and miraculous.

Each daily reading will take you only a few minutes. But the daily rehearsing of these truths will change your heart, your mind, and your perspective.

May you learn to enjoy God as much as He enjoys you.

day 1

Trained in the Truth

Precious Father, You are the source of all truth! Show me the lies I picked up when life let me down. Uproot the weeds, and together, let's plant new seeds of faith, hope, and love. Help me envision a new harvest of righteousness in my life. Teach me to walk in Your ways with such consistency and confidence that I'm no longer moved by the storms that once shook me. Holy Spirit, quicken me from within, lead me into all truth, and set me free in ways I never dreamed possible! You are good. Your promises are true. And You will always make a way for me. Amen.

Our Enemy sees our potential long before we ever do. He starts when we're young and not only targets our gifting and future calling, but he also goes after those tender places of vulnerability. All you need to do is look back into your childhood, and you'll likely find a pattern of losses and hurts that conflicts with God's message of hope and redemption for you. A friend

once reflected, "Our Enemy starts when we're young and conditions us to believe his lies."

Why does he do that? If we're conditioned to believe lies, he can steal from us without us ever even realizing it. If you think you're an outsider, you'll assume God doesn't have a community for you, and you won't contend for it. If you believe you're a reject, you'll allow the Enemy to use every hardship and setback to confirm that you're unacceptable. Those trials are meant to train you to be strong in battle and secure in your identity. If you believe you're only a victim of your circumstances, you'll never dare to imagine and fight for your victory. The truth is, no demon in hell can keep you from all God has for you!

If you believe God is the one who made you ill or caused you pain, you'll feel conflicted about contending for your healing and restoration. If you don't know all Jesus won for you, how will you know when it's stolen?

In every way, the Enemy takes God's ideas and counterfeits them. He has a history of conditioning us to believe his lies. Thankfully, God has a history of continually setting us free.

> The righteous person faces many troubles,
> but the LORD comes to the rescue each time.
> Psalm 34:19

The beautiful thing about Jesus is that He's not impatient with us. He knows how perpetually we fall into the Enemy's traps and how quickly we believe his lies. But He does intend for us to mature and grow. There

are things He wants us to know—some of which we're not ready for until we've won some victories and have gained new ground. Because our healing most often comes in layers, so does our knowledge of and capacity for the truth.

Every time you decide to hold fast to God's truth in the face of contrary circumstances, you grow in knowledge of God and His ways. Every time you rehearse the truth about who you are because of who God is, you reinforce the truth in your innermost being, which is a good thing because that's where most lies go to hide.

> Behold, You desire truth in the innermost being,
> And in the hidden part [of my heart] You will make
> me know wisdom.
> Psalm 51:6 AMP

God is so good. He intends for you to gain wisdom, authority, and credibility where you've experienced loss, heartbreak, and messages that distort His love. Train yourself in the truth that sets you free.

Picture yourself tightening that belt of truth around your waist (Ephesians 6:14). It holds the rest of the armor in place. Imagine yourself walking through the ashes of your pain with your head high, your shoulders back, and your heart warmed by the fact that you belong to God—the Redeemer of your story. These things are possible with God.

FAITH DECLARATION

Jesus is alive!
His Words are true!
I am loved.
And I walk free!

BRAIN RETRAIN

My new beginning starts today.

FURTHER STUDY

Romans 8:6; Philippians 4:8

MY RESPONSE

day 2

Believe God for Good Things

Good and gracious Father, thank You for loving me like You do! You are good, and You are kind. You know my story inside and out, and You are redeeming every part of it. I can trust You. Thank You for the countless ways You provide for me. Things I notice and things I miss. Things I cherish and things I take for granted. You're intimately involved with my life, and I can trust You. Thank You, Lord. Amen.

Sunrises. Sunsets. Belly laughter. Frosted brownies. A colorful salad. A fluffy pillow. Water to drink. Clothes to wear. Friends and family to love. New mercies every morning (Lamentations 3:22–23). Unending faithfulness at night. Eternal security. Moment-by-moment grace. Jesus alive in you. Jesus all around you. The promise of His presence and access to His power.

You're not just blessed; you're profoundly, abundantly, and lavishly cared for.

Imagine it: God the Father watches over you. He charges angels to intervene for you and protect you (Psalm 91:11–12).

Jesus died for you. He continually intercedes for you. And He's coming back for you!

The Holy Spirit is alive in you. He gives you peace. He cautions you. He comforts, corrects, and directs you. He imparts wisdom and knowledge you'd never otherwise possess.

Even now, your Good Shepherd goes before you and clears the path for you. He's got your back and will defend and deliver you. And He's right beside you, within you, affirming His work in you.

I read this verse years ago, and it's never left me:

> **You go before me and follow me.**
> **You place your hand of blessing on my head.**
> **Psalm 139:5**

Even so, it's hard to see and enjoy the goodness of God when pain, loss, or heartache are all we feel. At times, I felt like I lived my life behind plexiglass. I could see God's gifts, but I didn't feel well enough to enjoy them. Pain compels us to look down. Faith invites us to look up.

It's one thing to count your blessings. It's far more powerful to attach each gift to a God who fiercely loves you. That takes some time, but it'll change how you think and feel. For instance, consider the food you'll eat today. You have choices about what to eat. You won't go hungry today. Before you put a bite in your mouth, pause and thank God for providing such a gift to you in such a personal way. Train yourself to connect every

morsel of food to a loving Father who provides for your needs. Over time, you'll feel grateful for the simplest things.

If we possessed perfect spiritual clarity, we could look around and notice that every single good thing in our lives comes with a gift tag attached: "To you. From God."

May God open our eyes to see gift tags everywhere we turn!

Every good gift bestowed, every perfect gift received comes to us from above, courtesy of the Father of lights. He is consistent. He won't change His mind or play tricks in the shadows.
James 1:17 THE VOICE

If you were able to gather all the gifts you've received from God from birth to now, your knees might buckle right under you. And how about the intangible gifts? The fact that God is consistent and steady and true is a treasure beyond measure. No one can gossip enough about you to make God change His mind about you. On your worst day and on your best day, He loves you the same, because that's who He is. All these priceless treasures belong to us because we belong to Him!

> Every single good thing in our lives comes with a gift tag attached: "To you. From God."

Someone once asked me, "If tomorrow you possessed only what you thanked God for today, what would you have?" It's a piercing question. And an important one.

Counting your blessings is better than complaining about your hardships. But holding each treasure before the Lord and acknowledging

His very specific love for you? It'll change your life. Why? Because with each gift you notice comes a message to your heart that your heavenly Father sees you, knows you, loves you, and has promised to take good care of you.

When you train your thoughts and your gaze to look for the gifts from God's hand, you'll start to believe—down deep in your bones—that you not only have a history with God, but you have a future with Him too. It's impossible for Him to fail you.

FAITH DECLARATION

*Because of Jesus,
I'm secure.
My God is faithful.
I have everything I need.
It's impossible for Him to fail me.*

———

BRAIN RETRAIN

I choose to believe that God is good.

———

FURTHER STUDY

Exodus 34:6; Psalm 23:6

day 3

Recipe for Vitality

Heavenly Father, I love You! I don't want to live exhausted, depleted, and passive in my faith. I want to come alive, burst with hope, and abound in holy ambition to live out my purpose as You intended. Awaken my soul. Show me how to course-correct so I run with purpose in every step. Speak! I'm listening. Lead! I'm following. In Jesus' name I pray, amen.

Nothing wears us out faster than giving our time to things Jesus never asked of us. When we forget who we are and who God is, we often misuse our time, treasure, and talents trying to prove something Jesus already established and won for us.

If God peeled back the sky for just a moment and you caught a glimpse of His compassion and love *for you*, you'd fall to your knees. If Jesus suddenly appeared in front of you, held your face in His hands, and spoke to you about your worth, your calling, and the places in you He intends to

heal, you'd instantly know which of your commitments don't belong on your schedule. The more genuinely we come to know the heart of God, the more clearly we discern our worth and calling.

> The more genuinely we come to know the heart of God, the more clearly we discern our worth and calling.

Yet even the most seasoned Christians can find themselves overcommitted to the point of exhaustion. We want to help. There's a need no one else is filling. It's just one more thing.

But over time, we start to feel more tired than energized. And eventually, we lose our sense of holy expectancy. Far too often, exhaustion leads to passive faith.

People who are busy with good things but not God-appointed things often find themselves squandering time instead of redeeming it. They're moving so fast that life becomes a series of shortcuts that leave them shortchanged.

When we're exhausted, we tend to loosen our grip on the promises of God. But Jesus has compassion for the exhausted, worn-out, weary heart. He invites us to come to Him to find rest for our souls and a fresh perspective on our lives (Matthew 11:28–30).

When God delivered the Israelites from Egypt, He delivered them not only geographically but also vocationally. For many years the Israelites had labored as slaves under harsh rulers and impossible conditions. They suffered, complained, and cried out to God. And their cry reached His ears. God moved! He mobilized a man named Moses and prepared His people to walk free. God was writing a new story for His people. Woven into that narrative was a rhythm of rest. This was a brand-new way of living!

Were the Israelites quick to adapt to a life of freedom and a healthy rhythm of work and rest? Sadly, they were not. In fact, their hardship was so hardwired into who they thought they were that they consistently found reasons to complain despite the many miracles God performed on their behalf.

Unfortunately, their grumbling hearts kept that generation out of the promised land.

While thinking about their story, I stumbled upon this passage in Hebrews, and it leaped off the page for me. Whenever that happens, I like to read the verses in several translations. Here's the verse:

> Indeed we have had the good news [of salvation] preached to us, just as the Israelites also [when the good news of the promised land came to them]; but the message they heard *did not benefit them*, because it was *not united with faith* [in God] by those who heard.
>
> Hebrews 4:2 AMP (emphasis added)

Here's what jumped out at me: God's chosen people cried out to Him because of their slavery. Yet all God's provision, all His promises, *did not benefit them* because when His answer finally came, *it was not united with faith*. They complained to God, but their hearts weren't receptive to God when His answer finally came.

Vitality comes from deep rest and purposeful faith. Our faith grows passive when we're exhausted from unappointed work—assignments that God never asked of us. Even so, God invites us to find what we need in

Him, and when He revives us, vitality returns once again. Isn't He just so good to us?

In her book *Embracing Rhythms of Work and Rest*, Ruth Haley Barton wrote:

> I know what it is like to rest for hours until I have energy to delight in something—savory food, a good book, a leisurely walk, a long-awaited conversation with someone I love. I know what it's like to feel joy, hope, and peace flow back into my body and soul when I thought it might never come back again. I know what it's like to see home and family, friends and community, differently through sabbath eyes of delight in God's good gifts. I have experienced rest that turns into delight, delight that turns into gratitude, and gratitude that turns into worship. I know what it is like to recover myself so completely that I am able, by God's grace, to enter back into my work with a renewed sense of God's calling and God's presence.[3]

Pay attention to the condition of your soul. If you're worn out and weary and find yourself loosening your grip on the promises of God, create some time and space to rest and be refreshed. Ask God to revive your soul and remind you of His promises. He'll answer you.

And when God moves, *activate your faith*. Receive His provision and wisdom with a heart of expectancy. You'll bounce back before you know it. And hopefully, you'll learn to enjoy running your race at the pace of grace.

Deep rest and purposeful faith is the recipe for vitality.

Because of Jesus,
I have enough time to do everything
God has assigned to me.
I work with purpose, and I rest by faith.
God's rhythm of work and rest for me
is kind, generous, and miraculous.

BRAIN RETRAIN

I can rest while God works.

FURTHER STUDY

Psalm 4:8; Psalm 91:1

MY RESPONSE

day 4

Develop a Habit of Hope

Dear Father, thank You for working wonders in and through me. Continue to lift my chin until my gaze instinctively turns upward. You've lavished Your goodness on me. You've surrounded me with Your promises. And You've delivered on Your Word. Lord, meet me in this place. Instill within me a renewed sense of optimism and expectancy. Help me cultivate a hopeful heart daily until it's the most instinctive, natural thing in the world. You're amazing, God. My hope is in You today. Amen.

―――――――――

I recently developed a habit that I'm pretty sure is good for me. At least, I hope it is. Every day after lunch, I take a couple of bites of an organic dark chocolate (nondairy, low-sugar) sea salt bar. I'm telling you (and myself) that I do this for detox purposes because, you know, it's dark chocolate. But I also admit, I look forward to that little treat every afternoon around one o'clock.

We all have habits—some we're conscious of, and others not so much. Bad habits are easy to come by. We naturally gravitate toward shortcuts, quick relief, and instant gratification. All of these are the soil for bad habits.

Good habits are born out of vision, hope, and a sense that our small daily choices are building momentum in our lives that will be worth it in the long run.

I mentioned in the introduction that I'd developed a habit of bracing for impact, which I hadn't realized until my friend challenged me to be honest about my inner dialogue. I never *planned* to establish such a posture, but I sure practiced it. Repeatedly. With every difficult day and every scary symptom of my illness, I allowed my fears and disappointments to win the day. Instead of challenging my inner narrative, I lived with it. And this impacted how I showed up in life. It makes me sad to think about it now. I'm so grateful God interrupted my plans to be miserable.

Pain, suffering, and delay will automatically negatively impact our posture unless we determine to reframe these things redemptively. I'm not saying we should pretend bad things don't happen. They do. But when we give more weight to our problems than we do to God's promises, we view life through a distorted lens. We begin to project our fears into a future God is not in. Yet for the believer, no such future exists. There'll never be a moment today, tomorrow, or any other day when God is not intimately close to us and profoundly aware of what we need.

God's promises are far more potent than our problems. His goodness far exceeds the Enemy's badness. There's no trial in our lives that God can't redeem one hundred times over. Even now, He's answering some of your prayers and moving things around on your behalf.

When we *anticipate* and *look forward to* the wonderful ways God is moving in our lives, it's far better for our souls (and our cells)! This is my prayer for you and for me:

> **May the God of hope fill you with all joy and peace in believing [through the experience of your faith] that by the power of the Holy Spirit you will abound in hope and overflow with confidence in His promises.**
> **Romans 15:13** AMP

How do we develop a habit of hope?

Every day, we live continually aware that God is with us and that He is always up to something good. His character doesn't change just because our seasons change. We ask God to fill us with hope, activate our faith, and open our spiritual eyes to see His movement. We purposely and continually lift our gaze upward with expectancy.

Using the acronym HOPE, here are four areas where God wants to revive a fresh sense of hope in you and me.

H—*Healing.* Everyone needs healing of some kind. Do you believe God wants to heal and restore what's hurting and broken in and around you? You may have trouble believing this right now. But I pray that by the end of the book, you'll learn to anticipate good things from God every day. Maybe it's hard to imagine

> When we *anticipate* and *look forward* to the wonderful ways God is moving in our lives, it's far better for our souls (and our cells)!

physical healing, but can you picture your soul being restored? Your sense of identity and purpose being renewed? What might a more healed you look like?

> He heals the brokenhearted
> And binds up their wounds [healing their pain and
> comforting their sorrow].
> Psalm 147:3 AMP

O—*Overcoming.* Everyone needs to know that they can overcome in life. Do you believe—despite all you've been through—that you will win a sound victory against the Enemy of your soul? Most of our victories come a little at a time, and they look different than we imagined. But one way or another, God has established us for victory and the devil for defeat. Believe it. Hope for it!

> No, despite all these things, overwhelming victory is ours through Christ, who loved us.
> Romans 8:37

P—*Purpose.* Everyone needs to know they have a purpose. Do you believe God wants to use you in this world in a way that far exceeds your gifts and abilities? That He wants to use you to bring healing and hope to the world? God has mastered the art of making miracles from our messes. He takes broken people and works powerfully in and through us. Believe it! Hope for it!

We are God's masterpiece. He has created us anew in Christ Jesus, so we can do the good things he planned for us long ago.
Ephesians 2:10

E—*Eternity.* All believers need to know that God will lead them safely home. And that what He has planned for us will take our breath away. He invites us to live now with eternity in mind. Every choice we make today has eternal implications. Believe it! Live like it's true!

What we suffer now is nothing compared to the glory he will reveal to us later. For all creation is waiting eagerly for that future day when God will reveal who his children really are.
Romans 8:18-19

FAITH DECLARATION

Because of Jesus,
and in Jesus' name,
I am healing.
I'm an overcomer.
I have a God-given purpose.
And I live with eternity in mind!

BRAIN RETRAIN

I am practicing hope today.

Jeremiah 29:11; Romans 15:13

MY RESPONSE

day 5

Spring Is for Real

Precious Father, You are alive and well! You are joyful and powerful and active on the earth today. Open my eyes to see glimpses of Your glory every which way I turn. Show me the sprouts of new life springing up all around me. Seasons change. Life renews. The old passes away. You make all things new. Renew my perspective, health, strength, and faith today. Help me believe that You love to see me flourish. In Jesus' name I pray, amen.

The winter season seems to last forever in Minnesota—at least for those of us who love heat, sunshine, blue skies, and dry roads. I remember a time many years ago when the anguish of my soul lasted so long it blurred the seasons for me. I didn't notice that springtime and summer had come and gone. Sickness and medical bills weighed heavy on my heart. The contrast

between my life and my friends' lives left me sad and disheartened. That is, when that was all I focused on.

Eventually, I looked up and heard the Lord's gentle whisper to believe Him for something more, something new, something wonderful that was just for me. We were nearing the end of a long, cold, snowy winter. The mounds of snow at the end of our driveway stood about seven feet tall. But the sun's warmth began to melt the dirty snow. The birds returned to us with their joyful songs. I even noticed a few tulips that had pushed their way through the thick layer of snow.

One day toward the end of March, God gave us a sixty-degree day. Neighbors opened their windows. Kids played in the driveway, and not one wore a winter jacket. People took walks and happily greeted one another, thrilled to be out of hibernation.

Could this be real? Might God be changing my season just as He's turning winter into spring? I felt hope and expectancy arise within me. I dared to dream a little. What might God want to do in and through me in the days ahead?

The following day, we woke up to brutally cold temperatures, gray skies, and howling winds. The icy snow blew sideways like an angry sandstorm. I looked out the window and felt sick to my stomach. I said under my breath, "That spring day was a lie. It seems winter will never end."

Just as quickly, the Lord's voice thundered in my ears: *No, no, no! You're wrong! This cold winter day is the lie. The promise of spring still stands. Spring is for real! Springtime is on its way, and nothing can stop it. Learn from this moment. When I deliver My children out of seasons of suffering, the trauma can linger within, making the lies more believable than the truth.*

Don't look back; look forward. I am doing a new thing. Do you not perceive it? I'm making a way for you. I want you to retrain your thoughts so you're quick to see the new and not so pulled back by the old. Yes, the winter seasons come. But winter always has an end. And springtime soon follows.*

The sunny, happy day you experienced? That was a glimpse of My glory. It's a taste of things to come, not something I tossed your way to trick you. I want you to flourish. I want you to believe that I'm always up to something good. The sooner you believe it, the sooner you'll see all I'm up to on your behalf.

In the book of Jeremiah, God told us we're blessed and wise to make Him our hope and confidence. When we trust Him more than we trust our circumstances, we learn to thrive in every season, regardless of the weather. Here's the passage:

> But blessed are those who trust in the Lord
> > and have made the Lord their hope and
> > > confidence.
> They are like trees planted along a riverbank,
> > with roots that reach deep into the water.
> Such trees are not bothered by the heat
> > or worried by long months of drought.
> Their leaves stay green,
> > and they never stop producing fruit.
> Jeremiah 17:7-8

Ponder that passage for a while. When we shift all our hope to Jesus, we're nourished regardless of droughts, long stretches of heat, and endless

months of winter. Our leaves stay green, and we never stop producing fruit.

Interestingly, the verses prior also tell us something we need to know:

> Thus says the LORD:
> "Cursed is the man who trusts in man
> And makes flesh his strength,
> Whose heart departs from the LORD.
> For he shall be like a shrub in the desert,
> *And shall not see when good comes,*
> But shall inhabit the parched places in the wilderness,
> In a salt land which is not inhabited."
>
> Jeremiah 17:5-6 NKJV (emphasis added)

We stunt our own growth when we take our eyes off God. Worse yet, *we won't see goodness when it comes.* Good always comes. But we'll miss it if we fix our eyes in the wrong direction.

Our God is a good, good Father. He gives His children amazing, personal, specific gifts because He knows us inside and out. He knows what will bring delight to your heart and how to heal you from all you've endured. If you've walked through a long stretch of winter, it's time to remind yourself that spring is coming—for real.

If you've walked through a long stretch of winter, it's time to remind yourself that spring is coming—for real.

God is good.
I am loved.
Life springs up.
And I will flourish.

BRAIN RETRAIN

God is doing something new in me.

FURTHER STUDY

Isaiah 40:31; Isaiah 43:19

MY RESPONSE

day 6

Anchored Upward and Forward

Father, You are the maker of heaven and earth. You are my Shelter, my Strong Tower, and my Deliverer. Your Word is unshakable. Your promises are impenetrable. Your love is unfathomable. Though I cannot fully grasp Your goodness, help my heart find its home in You. I'm safe and secure because I am Your beloved child, and You have no rival. Awaken my heart so I may see my story with eyes of faith. Amen.

God wants to move us out of bracing for impact and into a lifestyle of anticipating His goodness. He wants us to live with holy expectancy and *believe* He's always up to something good. Whether we perceive it or not, God *is* in the process of redeeming our story.

Bracing for impact is terrible for our souls and for our cells. Living in fight-or-flight mode affects digestion, sleep, how we process information, and so much more.[5] We're not meant to live bracing for impact. But

equally jarring is living with a low level of discernment so you don't see a storm when it is brewing overhead.

Living with holy expectancy will heal you from the inside out. Living simultaneously with heightened discernment will keep you several steps ahead of the Enemy so you don't get whiplash when the storms of life come.

The other day, while I was driving through a car wash, God surprised me with insight that gave me pause but also offered me peace. He prepared me for news that would come the following day, information that I wouldn't like. I knew I'd heard Him. I decided to trust Him. Still, the next day, the tough news hit me harder than it should have, like a punch to the gut. Why did that happen when God had been kind enough to prepare me?

In my book *Fully Alive: Learning to Flourish—Mind, Body, & Spirit,* I write about another time (another storm) when God thundered this wisdom into my soul: *The storms reveal the lies we believe and the truths we need.*[6]

God allowed this current storm to show me that I had shifted my hope onto an outcome that I had no business hoping in. God's goodness this time was revealed in His Fatherly warning: *I just want you to know that this isn't going to turn out the way you'd hoped. But I am your strong tower; I am your provision. I will take care of you.*

God knows our hearts so intimately and intricately that He knows what kind of goodness we need. Had He not warned me the day prior, the disappointing news would have capsized my perspective. And though I needed a moment to find my footing, it didn't take long for me to see the sun break through the clouds and for hope to arise once again.

Hoping in anything but God is a dangerous proposition. Remember

this: God's hold on you is firmer than your hold on Him. The storms will always reveal where your hope lies.

> God has given both his promise and his oath. These two things are unchangeable because it is impossible for God to lie. Therefore, we who have fled to him for refuge can have great confidence as we hold to the hope that lies before us. *This hope is a strong and trustworthy anchor for our souls. It leads us through the curtain into God's inner sanctuary.*
> Hebrews 6:18–19 (emphasis added)

Why do we continually grab for what cannot satisfy, let alone save us? God, in His kindness, reminds us time and time again that our safest place is with Him. And it's not just our safest place; it's the very place where His presence and power dwell. We live with otherworldly insight, power, and revelation when we dwell with God. He intends to empower our steps, clarify our vision, and awaken us to the reality that all of heaven is on our side.

In his book *Help Is Here*, Max Lucado wrote about a "row-boat" faith, one powered by our own strength, versus a faith more like a sailboat, powered by the wind:

> Row-boat Christianity exhausts and frustrates. Those who attempt it are left depleted and desperate at the attempt. Those who let the Spirit do the work, on the other hand, find a fresh power. . . .

We cannot fulfill our mission on our own. We do not have the strength, resolve, or power. But the Spirit does. So trust him. Hoist the sail, take a breath, and enjoy the ride.[7]

We are tethered to a good, loving, and protective Father. We are anchored upward—into the very throne room of God—and forward—into our future, where God already exists and has written a beautiful story with our lives.[8] He's got you, and He won't let go. It's impossible for Him to fail you.

We're secure even on our insecure days. We're tethered even when the storms toss us around. We're kept by the One who has promised to get us safely home. A glorious future awaits us.

> We are anchored upward—into the very throne room of God—and forward—into our future, where God already exists and has written a beautiful story with our lives.

FAITH DECLARATION

Because of Jesus,
I am calm, confident, and assured.
I'm not at the mercy of this storm.
I'm in the mercies of God.
And He is good.

I am securely tethered to God, and I trust Him.

———————

Psalm 16:8; Psalm 18:1-3

MY RESPONSE

day 7

Dare to Dream

Father, I come boldly into Your presence, knowing—with all my heart—that You're glad to see me. I'm Your child—beloved, healed, and whole—and I'm in the process of becoming more like my Savior with each passing day. Your Spirit is alive in me. I've got breath in my lungs today because You have much You want to do in and through me. Awaken me to the possibilities before me. Help me pray for and believe for things that only You can accomplish. I'm Your vessel. Flow freely and powerfully through me. Amen.

Many years ago, I worked as the group fitness coordinator for a high-level health club system. The facilities were beautiful, and our instructors were certified and top-notch. It was a great job, and I loved our members. Still, I had a feeling that I was a few degrees off course, that God had something much more significant for me to do. I wondered about it and prayed about

it, but otherwise, I stayed, with the challenge of balancing my work with my family and church life.

One day I sat in a managers' meeting while one of our VPs led us through a training exercise. He said, "Picture yourself at the end of your life. You're ninety-five years old, on your deathbed, and you're looking back over your life journey. Take out your notepad and write this statement at the top of the page: 'I wish I would have.' Then finish that sentence as many times as you need to." He stepped away from the podium and gave us time to think about our answers. I didn't need to think about it. I put my pen to the paper and wrote, "I wish I would have written a book."

I'd been through a lot. God had been so faithful. Yet I felt myself drifting. I was no longer in crisis. But neither was I taking steps toward the God-given longing of my heart. When there's no vision in our hearts, there's no purpose in our steps. And when there's no purpose in our steps, we drift to lesser things that drain the vitality right out of life.

After work that day, I went home and told my husband, Kev, about the meeting and how I finished my statement. He paused thoughtfully and then said, "You *must* write a book. That's one of God's purposes for you." We looked at our finances and made some strategic plans for me to quit when the time was right, and I explored the world of writing.

Regarding God's promises, He invites us to engage with Him consistently. Stress doesn't exhaust us; stress without purpose does. It's not waiting for the breakthrough that drains us; it's passively waiting without activating our faith that robs us. We're wired for tenacious, hope-filled, purposeful faith. Allow me to put it this way: *What are you believing God for?*

Anyone who's adventured to step out in faith knows this: when we

finally dare to dream, opposition arises. But we can put up with a lot when we know we're on God's best path for us.

Not every desire in our heart is God-given. But many are. If you walk intimately with God and treasure His Word in your heart, He'll shape your desires to match His desires for you. He'll prepare you to steward the dream. He'll confirm His will and way to you repeatedly. When You delight in Him first and foremost, He will always establish you in His perfect will and timing.

> **Take delight in the LORD,**
> **and he will give you your heart's desires.**
> **Psalm 37:4**

About eight years ago, God prompted a dear friend to pray for a birthday miracle. He whispered an invitation to her heart, and she responded expectantly. She earnestly prayed for answers that would have been impossible apart from God. Yet the more she prayed, the more those prayers fueled her faith and energized her steps. She became a woman on a mission.

Not only did God miraculously break through with the birthday miracle she had prayed for, but He also invited her to pray for birthday miracles for others. And Easter miracles. And Christmas miracles. She is a prayer missionary. She asks Jesus who needs a miracle. She fasts for them leading up

> If you walk intimately with God and treasure His Word in your heart, He'll shape your desires to match His desires for you.

to their birthday or the upcoming holiday. And God continually confirms her calling by doing the miraculous through those prayers.

What about you? Picture yourself at the end of your life, looking back over your years. What would you wish you had done? How about asking God to help you take your first steps today? Your life on earth is the only time you'll get to exercise your faith because one day, your faith will become sight. Now is the time to cultivate a faith that blesses God's heart. Today is the day to trust Him.

FAITH DECLARATION

Because of Jesus,
I am loved and called,
anointed and appointed.
I'm daring to dream new dreams.
God is doing a new thing in me!

BRAIN RETRAIN

I dare to dream new dreams.

FURTHER STUDY

Ephesians 2:10; Ephesians 3:20

day 8

Strategically Reject and Accept

Father in heaven, holy is Your name. May Your kingdom come, and Your will be done, on earth and in my heart as it is in heaven. Lord, show me my heart! I've put up with too much from the Enemy of my soul, but no more! I'm done listening to his lies. I'm fine-tuning my ears to You, Lord. Speak what's true. Breathe fresh life into my soul. Heal my heart, and make me whole. Give me feisty faith so I can walk in freedom. Amen.

I sat across the table from my friend, and we enjoyed an easy banter. Suddenly the conversation shifted to a painful relationship issue she was walking through. Her brow furrowed, and her jaw muscles flexed. Just then, our server interrupted us to refill our water glasses. I watched my friend as she stared out the window. Her countenance darkened, and the light went out of her eyes. Her fists clenched, and the previous sense of hopeful expectancy vanished.

Once the server walked away, I touched my friend's arm. She stared out the window and didn't flinch. "Hey," I said. She looked back at me. I continued, "Tell me where your thoughts went just now." She shook her head and said, "What? No. I'm fine. It's nothing." I leaned forward and said, "It's not nothing. Tell me what just happened in your heart and mind. Where did your thoughts go?"

She relaxed her hands, exhaled, and confessed that she'd spiraled into the ditch of anger, despair, and hopelessness. Together, we disentangled her thoughts from the lies she believed and helped her grab hold of the truths she needed. Then we prayed and asked our Father to intervene. My friend is a woman of God. And by the time we parted that day, her joy had returned, and her faith was fully engaged.

How do we discern when we've wandered off track? It's simple. Do our thoughts bring life and peace (Romans 8:6)? Or not? It's good to ask ourselves these questions each day, and sometimes several times a day:

What am I accepting, and what am I rejecting in my heart and mind? And how are these choices affecting my perspective and faith at this moment?

Scripture tells us to guard our hearts with the diligence of a prison guard on duty, fully alert and completely aware of his responsibilities (Proverbs 4:23). Imagine the boundaries of your heart. Only truth belongs there—God's truth that heals, reveals, guards, and guides. The lies will continually poke at you, trying to find an opening or a vulnerability. The lies will rob you of all God has for you.

Diligence calls us to keep the right things in and the wrong things out.

Far too often, we're lackadaisical regarding the issues of our hearts. We allow insecurity to linger unchallenged. We open the door to fear. We continually rehearse thoughts that weaken us. We think nothing of holding grudges and making careless judgments. We have no idea how these poisonous roots choke the life right out of us. God forgive us.

Yet God, in His kindness, teaches us how to tend to our hearts in the middle of hardship and heartbreak. Though it's tougher to stay hopeful amid suffering and expectant amid hardship, it's what our souls need. That's where spiritual heroes are made.

> Diligence calls us to keep the right things in and the wrong things out.

After God set the Israelites free from slavery in Egypt, they prolonged their journey through the wilderness—so much that the first generation never made it to their promised land. They coddled their fears more than they clung to the promises of God. Some would say that though their fears at first were understandable, those same fears eventually made them rebellious. They *refused* to believe God.

> The people *refused* to enter the pleasant land,
> for they *wouldn't believe* his promise to care
> for them.
> Instead, they grumbled in their tents
> and *refused* to obey the Lord.
> Psalm 106:24-25 (emphasis added)

God has a next place of promise for you. He's committed to love and care for you. He calls you out of the smallness of your circumstances (like the Israelites grumbling in their tents) to behold the vast landscape of hope and life He's prepared for you. God has also given you free will—the right to decide which attitudes you'll embrace and what perspective you choose to live with. All of these choices have consequences.

You have the right to accept one thing and reject another.

May you become a skillful and godly warrior. May you be quick to discern and reject the Enemy's lies. And may you be quick to accept and embrace God's truth that will set you free. May you become mighty in God.

FAITH DECLARATION

Because of Jesus and in His name,
I reject rejection!
I accept acceptance!
I am loved, called, and chosen.
I'm highly discerning, and I walk in freedom.

———

BRAIN RETRAIN

I reject rejection and accept acceptance.

———

Proverbs 3:5-6; Proverbs 4:23

day 9

Fearfully and Wonderfully Made

God of all comfort, thank You for loving me! I am more blessed than I can fathom because You are with me every moment of every day, closer than my next breath, and intimately involved with every detail of my life. You thought about me before I was born, and Your thoughts toward me outnumber the sand on the shore.⁹ And every thought You think about me is holy, redemptive, and life-giving. How can it be? Yet it's true! Help me live securely in Your love today and every day. Amen.

———————————

When God first thought of you, you didn't exist yet. He so loved the idea of you that He *created* you in your mother's womb. You're fearfully and wonderfully made. Do you believe it? Can you say, along with the psalmist, "I am fearfully and wonderfully made…And that my soul knows very well" (Psalm 139:14 NKJV)?

God loves what makes you laugh, and He cares about what makes you

cry. He created you with specific passions and imparted to you certain gifts—to know and enjoy you as you walk intimately with Him. The more you trust His love, the more instinctively and supernaturally you'll reflect His power and presence to a world in need.

Our Father is so brilliant that He *merely spoke*, and the heavens came to be.

> The LORD merely spoke,
> and the heavens were created.
> He breathed the word,
> and all the stars were born.
> He assigned the sea its boundaries
> and locked the oceans in vast reservoirs.
> Let the whole world fear the LORD,
> and let everyone stand in awe of him.
> For when he spoke, the world began!
> It appeared at his command.
> Psalm 33:6-9

Without exerting Himself, God created the heavens and the earth. And with great excitement, He created *you*. You are His work of art, His masterpiece (Ephesians 2:10).

Though we are a pile of contradictions (we're grateful and grumpy on the same day), God loves us. Though we forget who He is and who we are, He never stops teaching us. Though we grab for ourselves and neglect to seek Him, He provides for us. His compassions never fail (Lamentations 3:22).

Think about that for a moment. You trip up, gain a few pounds, or speak out of turn and instantly turn on yourself. But what is God's response to your foibles and inconsistencies?

He sends new mercies to your door every single morning. He faithfully walks with you throughout the day. He reminds you of His love at night. His Spirit whispers from within and teaches you a better way to live than what you choose for yourself.

Never does He stop loving you. Never does Jesus stop interceding for you. Never, ever, ever will God abandon you or forsake you. He's intimately involved with your story today, and He'll make sure you get safely home when your time on earth is done.

Still, we're surrounded by thousands, if not millions, of messages telling us otherwise. That God is aloof. That we don't matter. And that everything is left to chance. Yet none of that is true. Sometimes it feels true, but on your worst day, it's still not true.

You were created by God Himself, and the sooner you trust His opinion, the sooner you'll get on with the thriving, flourishing life to which your soul is an heir.

Why does it matter that we believe in God's goodness? Because the more aligned we are with the truth, the freer we'll be. The more we learn to rest in God's care, the more we'll enjoy who He really is. He's good and kind and loving. He's so taken with us that He delights in every single detail of our lives (Psalm 37:23).

Today is a good day to pay attention to the thoughts you're rehearsing. Do your most repetitive thoughts reflect God's amazing and precious thoughts toward you? Or are you out of sync?

No worries. Just start again today. No one gets to decide your worth. Not even you. You were created by God Himself, and the sooner you trust His opinion, the sooner you'll get on with the thriving, flourishing life to which your soul is an heir.

FAITH DECLARATION

Because of Jesus,
I am a masterpiece
created by God.
I've decided to live loved.
And I believe that God is good.

———

BRAIN RETRAIN

I am fearfully and wonderfully made.

———

FURTHER STUDY

Psalm 139:14; Isaiah 45:4–12[10]

day 10

Slay Your Inner Critic

Loving Father, thank You for Your Son! Jesus, thank You for defeating sin and death on the cross for me. Thank You for winning a sound victory over the Enemy! Because Your Spirit is alive in me, I am seated with You.[11] *Insecurity is just an illusion. I can't be more secure than I am right now. Help me live bravely and boldly and say no to every lie that trespasses against me. It's Your truth that sets me free. Awaken me today to the reality of Your goodness and the abundance of life I possess in You. Amen.*

God created you. He wired you for life, love, and freedom. He established you on the earth today for a divine purpose.

God intends for you to flourish so others can thrive too. He wants the world to be nourished by your anointed, appointed, abiding-in-Christ life. He wants your soul to be so free that it sparks freedom in others. He wants

your life to be so miraculous that many see your life and put their trust in the Lord. Like the psalmist wrote:

> I waited patiently for the Lord to help me,
> and he turned to me and heard my cry.
> He lifted me out of the pit of despair,
> out of the mud and the mire.
> He set my feet on solid ground
> and steadied me as I walked along.
> He has given me a new song to sing,
> a hymn of praise to our God.
> *Many will see what he has done and be amazed.*
> *They will put their trust in the Lord.*
> Psalm 40:1-3 (emphasis added)

It's important to note, though, that the Enemy has had your whole life to study you, to watch what makes you sad, breaks your heart, and steals your joy. He's a genius when it comes to his thievery in your life. Sometimes he plants thoughts in your mind and puts them in the first person. They may sound like, *I'm such a dolt. I can't believe I forgot her name. I'm so fat. Why can't I lose weight? I've never been a legitimate part of the group. My friends don't really like me. They mostly tolerate me.* The Enemy may plant the seeds, but we're the ones who often nurture those seeds to life (or to death, I should say).

Because the Enemy knows us so well, he knows how to plant thoughts we'll easily agree with. Years ago, someone said to me, "Every day, Jesus

intercedes for you. Every day, the devil accuses you. You're the one who casts the deciding vote." Our agreement matters greatly. Pay attention to the level of peace and life in your soul. Are you feeling troubled? Insecure? Disoriented? If so, guess who's behind it?

Your inner critic is a composite of the Enemy's lies, your past failures, and your current fears. Your inner critic's influence in your life is directly connected to your willingness to put up with its destructive narrative.

A mind set on the Spirit produces life and peace even in the middle of the storm (Romans 8:6). You have access to everything you need in Christ Jesus. And you have the authority to defeat your Enemy (Luke 10:19).

Since that's true, today's a good day to slay your inner critic. You need the Holy Spirit to bring you the correction and redirection your character requires. Your inner critic is cruel, unrelenting, and without compassion. Your inner critic criticizes and minimizes.

Jesus taught us that a house divided against itself cannot survive, let alone thrive (Matthew 12:25). Your inner critic and the Holy Spirit of the living God do not belong in the same house, let alone the same heart. It's time to serve an eviction notice to your inner critic.

> Your inner critic and the Holy Spirit of the living God do not belong in the same house, let alone the same heart.

The precious and powerful Holy Spirit breathes life and wholeness into the depths of your soul continually. The Holy Spirit guides you into all truth (John 16:13).

Ask God to show you how to evict your inner critic. Ask Him to teach you how to live in response to His great, powerful, convicting, and healing

love. He winces within you when you're wrong and floods you with peace when you're on the right track. Imagine God Himself residing in your soul as the Holy Spirit, sealing you for the day of redemption, helping you distinguish truth from lie, right from wrong, wisdom from foolishness. Imagine growing in such intimacy with God that His is the voice you always hear first.

You're kept by God Himself. You're not keeping yourself. You'd never make it home if you were. And God's heart bursts with love at the thought of you! He smiles when He thinks of you. He loved you yesterday. He loves you today. And He'll most certainly love you tomorrow. Walk free and live loved.

FAITH DECLARATION

Because of Jesus,
the cross has spoken.
The curse is broken.
Jesus is alive.
And I am free!

———

BRAIN RETRAIN

I am who God says I am.

———

Luke 10:19; Romans 8:6

day 11

Steward Your Words

Precious Father, You've entrusted much to me. Teach me to be a faithful steward. Impart a higher level of discernment and a deeper understanding of Your love. Help me be quick to fend off the Enemy's attacks and ruthless when it comes to his lies. Help me hold on to what is true and resist what is not. I can live with joy and peace in every season. You are healing, maturing, and awakening me to Your purposes. You're breathing new life in and through me. May I thrive because You are alive in me. Amen.

———————————

I hesitated to write today's reading because many have taken this idea to an unhealthy extreme. That's not my intent here. That said, let me dive in. Your words and your thoughts are gateways—opportunities for both God and your Enemy. The thoughts you agree with and the words you say ignite a momentum in your life that's unmistakable.

One night as a young mom, I remember crying out to God over my

illness and our medical debt. I prayed the Scriptures, asking Him to supply all my needs. But as soon as I finished praying, I stood up and heard myself say, "I don't see how we'll ever make it through this. We're going to be broke forever." The Holy Spirit winced within me. The Lord whispered to my heart, *So which of your words should I act on, Susie? My promise to provide, or your declaration that I won't?*

Scripture has a lot to say about the words we speak. Notice the verse below. Both *death* (which translates as *death*) and *life* (which translates as *revived from sickness, discouragement, faintness, and death*) are in the custody of the tongue.[12] Your cells, your soul, and your perspective respond to the story you're telling yourself.

> **Death and life are in the power of the tongue,**
> **And those who love it will eat its fruit.**
> **Proverbs 18:21** NKJV

God wants us to cultivate a lifestyle of anticipating His goodness. But how is that possible if we repeatedly rehearse phrases that at best weaken us and at worst allow the Enemy to use our words against us? What if there's something to this? I believe there is. Jesus said that whatever is in our hearts comes out of our mouths (Matthew 12:34).

One night, I tossed and turned when the Lord whispered, *I want you to stop saying that.* "Saying what?" I quietly asked. He said, *Quit saying phrases like, "That's unnerving."* I've said that

> Your cells, your soul, and your perspective respond to the story you're telling yourself.

countless times when referring to our culture. It never occurred to me that the word *nerve* was in that phrase. I was deeply convicted. Most of my troubling symptoms are neurological. I'm not saying my words caused the symptoms, but I want to close every door of access to those symptoms.

The following morning, I asked God to continue to speak to me. He showed me several phrases I've mindlessly repeated that directly connect to the symptoms I battle:

- "Oh, my heart!"
- "It rings in my ears."
- "Takes my breath away."
- "Makes me ache."
- "Keeps me up at night."

When I surveyed the list, I spouted, "My word!" And just as quickly heard the Lord say, *Exactly.*

Later that day, someone commented on how fast I tend to talk. I apologized and jokingly replied, "Yes. I know. It's a fatal flaw." Instantly, God convicted me again. *Really, Susie? I've entrusted You to be My ambassador, to speak My words. And you think that because you sometimes excitedly get going too fast, you should die for it? Or that talking fast is going to somehow kill you? Watch your words!*

I got on my knees and repented.

Some take this idea to a legalistic extreme, but may I ask, are there mindless phrases you say that the Enemy might be using against you? Do you say things that conflict with God's promises to you?

Prayerfully read through the following passages.

> **Some people make cutting remarks,**
> ** but the words of the wise bring healing.**
> **Proverbs 12:18**

> **A gentle tongue [with its healing power] is a tree of**
> ** life, but *willful contrariness* in it breaks down**
> ** the spirit.**
> **Proverbs 15:4 AMPC (emphasis added)**

Are your words wise, and do they ignite healing in and all around you? Because that's God's will for you and me. May the words of our mouths and the meditations of our hearts be honoring, holy, and life-giving for our good and His glory (Psalm 19:14).

FAITH DECLARATION

Because of Jesus,
I am filled with the Spirit of the living God.
I see what God sees.
I say what God says.
I love like Jesus loves.
And I pray like Jesus prays.

I choose life. I speak life.

—————————

Psalm 34:11-14; Psalm 141:3-4

MY RESPONSE

day 12

Believe and Therefore Speak

Mighty Redeemer, faithful God, You've given me access to Your presence, provision, and power—more than I could ever appropriate in my lifetime. I refuse to live an earthbound life. I want to lay hold of, fully embrace, and live out of Your goodness toward me. Show me what I believe, and then tell me what's true. Infuse my words, empower my prayers, and energize my steps with mountain-moving faith. You are mighty to save. I possess all I need in You! Amen.

I've struggled for more than three decades with daily symptoms of Lyme disease. Yet God has ignited more healing in these past couple of years than in all the other years combined. He's gone after the buried trauma that kept me bracing for impact. He's addressed the disappointment and hurt I felt toward Him because of the things I've suffered. He's even convicted me of some false comforts I turned to when it seemed He waited too long to intervene.

To be honest, I'm clunky at this. One moment, you'll find me testifying to something miraculous God did within me, and the next (if you find me on an off day), I'll sigh and sometimes sob over these dumb symptoms that never seem to go away. Yet God continues to call me higher and deeper regarding my words. He's shown me that our words are seeds that go into the ground and sprout in due time. I've planted both flowers and weeds. I want more flowers.

Again, this idea of speaking faithful words sometimes morphs into something extrabiblical. We don't dictate to God; He dictates to us. He's not a means to an end. He's the Alpha and Omega—the beginning and the end (Revelation 21:6). We're at His beck and call, not the other way around.

But didn't Jesus tell us to *speak* to our mountains?

"Truly I tell you, whoever says to this mountain, Be lifted up and thrown into the sea! and does not doubt at all in his heart but believes that what he says will take place, it will be done for him.

For this reason I am telling you, whatever you ask for in prayer, believe (trust and be confident) that it is granted to you, and you will [get it]."

Mark 11:23-24 AMPC

Years ago, I read a scientific study (not faith based) that explored how anxiety is often directly connected to rogue thoughts. They found that one thing that stops the flow of runaway thoughts is the spoken word.[13] You can interrupt an unhealthy flow of destructive thoughts by

speaking a life-giving flow of words! How much more so when you're boldly and bravely declaring God's living, active, and powerful words (Hebrews 4:12)?

Did you know that in some places in Scripture, the word *meditation* means to mumble, speak, and even roar God's Word out loud? God instructed the Hebrew people to *keep His Word on their lips* (Joshua 1:8), not just in their thoughts.[14]

Though I can't explain why complete physical healing has taken so long for me (while others get an instantaneous miracle), I can say that I'm literally infused with power when I remember God's promises and then roar them over my life on a regular basis. I'm planting a garden of truth all around me!

God wants us to know what Jesus won for us. He wants us to rehearse His promises and to remember that though we see many hardships in this life, there are significant benefits to being a child of God.

> O my soul, come, praise the Eternal
> with all that is in me—body, emotions, mind, and
> will—every part of who I am—
> praise His holy name.
> O my soul, come, praise the Eternal;
> sing a song from a grateful heart;
> sing and never forget all the good He has done.
> Despite all your many offenses, He forgives and
> releases you.
> More than any doctor, He heals your diseases.

He reaches *deep* into the pit to deliver you from
 death.
He crowns you with unfailing love and
 compassion *like a king.*
When your soul is famished and withering,
 He fills you with good *and beautiful* things,
 satisfying you as long as you live.
He makes you *strong* like an eagle, restoring
 your youth.
Psalm 103:1-5 THE VOICE

Even though you can't possibly use up all God has provided or fathom
the fullness of His love, why don't you try? Imagine yourself swimming in
the ocean of His goodness! He's made it available
to you. Saturate yourself in His holy provision.
Start speaking to the obstacles in your life. Tell
your body to heal, your mountains to move, and
your Enemy to be gone, in Jesus' name.

> Start speaking
> to the obstacles
> in your life.

FAITH DECLARATION

God is good.
His promises are true.
He will always make a way for me.
I speak, and mountains move
because Jesus Christ is alive in me!

God empowers my words and fuels my faith.

Proverbs 18:21; Proverbs 31:26

day 13

Move from Coping to Consecration

Glorious and mighty God! You are my Deliverer, my Defender, and my Strong Tower. My help and my hope are in You! Give me a vision for my next place of promise. Bring holy conviction to my ways of coping. At the same time, please envelop me with a renewed sense of Your kindness, compassion, and grace. You're not looking for perfection, but You are after my freedom and the total redemption of my story. Show me what holds me back, slows me down, and hinders my progress. It's the pure in heart who see God.[15] I want to see You for who You are. Purify my heart, my thoughts, and my ways. Lead me upward and onward. Amen.

I stood in my closet, trying to decide what to wear. I noticed several new outfits with tags still dangling from the hangers. What had I done? How

did I not see this before? I'm a serious follower of Christ. I love God's Word. I pray throughout the day. Jesus is my everything. Yet as I surveyed the clothes in my closet, I realized that over the past several months, I'd purchased several outfits I didn't need, to comfort me until my breakthrough came.

I was sick and tired of being sick and tired with no end in sight. I felt stuck in a land where breakthroughs never came. I don't even like to shop, but I love cute clothes. And I longed for something *new*. Why was God so silent? Why must I wait so long for the breakthrough?

I didn't even realize I'd found a way to numb my pain and disappointment. There's nothing wrong with a new outfit. But *our ways of indulging and coping reveal the things we believe about God*. When we unhealthily numb our pain, we diminish our discernment. When we grab for temporary relief because we don't trust God, we dull our spiritual senses so that we cannot discern goodness *when it comes*.

Buried in my soul—unbeknownst to me—was a belief that God wasn't going to be good to me, so I needed to be good to myself.

> Our ways of indulging and coping reveal the things we believe about God.

How often do we, as God's people, take matters into our own hands because we've not fully resolved that God is truly good? We profess He's good, but at best, we believe He's sometimes good. But only inconsistently so.

The problem with that mindset is it's untrue. And it will never bring the revival and refreshment our souls long for. Truth sets us free (John 8:32). In His presence fullness of joy is found.

> You direct me on the path that leads to a
> beautiful life.
> As I walk with You, the pleasures are
> never-ending,
> and I know true joy and contentment.
> Psalm 16:11 THE VOICE

There in my closet, I got down on my knees, opened my hands, and asked God to forgive me for taking the bait to believe something false about Him. My actions had proved my unbelief. Others may judge my actions as harmless, but I knew in my heart that my own coping had led me away from consecration.

God wants to do something new in and through us! Prayerfully read the following verse, and consider what God might be asking of you at this moment:

> Joshua told the people, "Consecrate yourselves, for tomorrow the LORD will do amazing things among you."
> Joshua 3:5 NIV

The word translated as "consecrate" in this verse means to sanctify, prepare, dedicate, be holy, and be separate.[16] The rest of the world may justify numbing indulgence, but the Lord God has something so much better for you. He offers you Himself. And He changes everything.

The moment I repented of my coping mechanisms and unbelief, God

filled me with peace and lavished me with grace. I sensed His kindness in a way that I almost couldn't bear. Yet I felt His caution and correction too. There's nothing wrong with enjoying some of the fruit of your labor, but we all know the difference between grace-filled freedom and weakening indulgence.

One important side note here: God lavishes grace on us. He understands fully how painful life on earth can be. He's not a cosmic killjoy waiting to pounce on our wandering ways. He's a good Father who aches for us when we're in pain. But He knows how devastating some of our coping mechanisms can be. And He wants to lead us on a path where we can mature, flourish, and live free from the bondage of addiction and unhealthy indulgence. He wants our souls to flourish.

Whenever we ask for more from God, He asks for more from us. As we mature in our faith, we learn to embrace His grace and revere His ways simultaneously. May we consecrate ourselves because God will do great things in our midst (Joshua 3:5).

FAITH DECLARATION

Because of Jesus,
I am holy and I believe I am healing.
I am called, chosen, and courageous.
I fear God and walk in wisdom.
I embrace grace and live in freedom.

I am growing in resilience.

———

Lamentations 3:23; 1 John 1:9

MY RESPONSE

day 14

Remember God Is with You

Loving Father, I want to know You more. Heighten my sensitivity to Your Spirit. Open my eyes to see Your movement in our day. Awaken my heart to believe You for the impossible. I refuse to settle into a place of unbelief. Fan the flame within me! This world is ripe for revival. Count me in. Meet me here. Help me gather with other believers who share my hunger. May we together call on You with holy expectancy. Holy fire, fall afresh on me! Amen.

One night, I had a few old friends over for dinner. We gobbled up chips and guacamole and caught up on life. After the meal, we gathered in the living room and snuggled in. I asked if I could play a couple of songs from my phone to set the stage for our prayer time. We all settled back, closed our eyes, and listened as a woman read Scripture passages accompanied by

a violin. The room suddenly felt different. A reverent awe filled our hearts. God was with us.

We all began to pray. We repented on behalf of our culture and where things have gone. We interceded for our children and for those yet to be born. Suddenly, the Holy Spirit stirred our hearts to more fervent and honest prayer.

We were at once aware of how often we self-protect and how it hinders the best of what God has for us. We repented of our desire for control and comfort and cried out more earnestly to God. We asked the Lord to do something in our day that we've never seen before.

I've been in plenty of prayer meetings over the years, but there was something incredibly sacred about that night. Joy, peace, and revelation flooded the room. When our prayer time ended, we looked at one another's tear-stained faces, and we asked, "What just happened here? What was that? Dear God, we must have more of You!"

All four of us in that prayer meeting have places in us that need healing, parts of our story that need redemption. We're still waiting. Yet when we brought ourselves before God that night, He granted us a glimpse of His glory. Instead of wondering if He'd come through for us, we begged Him to show us anything *within us* that might block our view of Him.

One of the ways you know God is moving in your midst is that your striving ceases, and your tendency to judge everyone else is blown to smithereens. You get a clear look at your own sinful tendencies, and it leaves you speechless. You come to grips with your mortality, your fragility, and your desperate need for a Savior, and you realize at that moment, praise

God, you have one. And you become profoundly aware that He is God, and you are not.

He's the same yesterday, today, and forever (Hebrews 13:8). He shines brightly on even the cloudiest days. Though darkness covers the earth, the glory of the Lord reigns and rules over all creation.

> Arise [from the depression and prostration in which circumstances have kept you—rise to a new life]! Shine (be radiant with the glory of the Lord), for your light has come, and the glory of the Lord has risen upon you!
>
> Isaiah 60:1 AMPC

My friends and I pondered our own desires. Have we been too easily satisfied with things that don't transform us? Have we even come close to plumbing the depths of God's goodness toward us? Might our desires not be too great but rather too small? What if God has more for us, and He's just waiting for us to more earnestly seek after Him?

We reflected on this famous quote from C. S. Lewis:

What if God has more for us, and He's just waiting for us to more earnestly seek after Him?

It would seem that Our Lord finds our desires not too strong, but too weak. We are half-hearted creatures, fooling about with drink and sex and ambition when infinite joy is offered us, like an ignorant child who wants to go on making mud pies in a slum because he cannot imagine

what is meant by the offer of a holiday at the sea. We are far too easily pleased.[17]

I want more of Him. How about you?

FAITH DECLARATION

God, You're good, kind, and powerful.
You're invincible, unfathomable, and accessible.
You know me, love me, and care for me.

BRAIN RETRAIN

I walk in God's presence as I live here on earth.[18]

FURTHER STUDY

Psalm 116:9; 2 Corinthians 3:17

MY RESPONSE

day 15

Keep Walking; Keep Believing

*Loving Father, thank You for being so attentive to the places in me
that still hurt. You haven't forgotten about me. You love me. And You're
patient with me. Though I'll be a work in progress until I see Your face,
I'm determined to enjoy the journey, embrace the pace, and cultivate a
lifestyle of holy expectancy. I know that healing often happens in lay-
ers. Help me trust You in the meantime. I'm not who I was. I'm not who
I will be. But today, I stand full of faith, knowing I'm loved, equipped,
and empowered to live a miraculous life with You. Amen.*

How do we live with joyful assurance when some of the longings of our
hearts remain unfulfilled? Is it possible to walk in the abundance of God
while you wait for the promises of God? Yes, I believe it is. But not without
utter honesty and holy dependence.

Holding on to God's goodness while we wait for Him to deliver on His promises is not for the faint of heart. And there are no tidy answers to the pain and heartbreak we endure. Yet God wants in on all of it. He wants access to every part of our story, even the days—especially those days—when we're so hurt by His delays that we want to run away.

Our lament is holy, purposeful, and healthy.[19] We don't turn away from God; we stay within His embrace and sometimes pound on His chest because of the angst in our souls. We're not orphans; we're heirs. We hurt as people of God, promised by God that all will one day be redeemed. So, for now, we learn to overcome until we break through.

We sincerely bring our story to our loving Father. We believe with all our hearts that He cares deeply and is already moving on our behalf. We know that our tender vulnerability and trust mean something to God. Our faith is precious to Him.

Let me give you an example. These past two years for me have been profoundly challenging healthwise. Two major surgeries, several complications, and tens of thousands of dollars later, I'm still recovering. I feel like I'm just coming out of that intense stormy season. I'm no longer in crisis mode. I feel myself starting to heal on the inside.

Even so, right now, on a scale of one to ten, my ears ring at a level twelve. I can barely hear myself think. Though so much is better than ever, my sleep is fragile and easily disruptable. And when I don't sleep well, inflammation rises, my neck goes numb, and I feel crummy.

One of my sons and his wife have battled infertility for almost seven years. This is the son who always had time for little ones. I felt sure he'd

have a large family by now. They're devastated and vulnerable and wondering where God is in it all. I cried over their heartbreak even today.

Does God care about all these stresses (and the ones I didn't mention)? Yes. With all my heart, I know He does. And He manages the universe at the same time.

> He heals the brokenhearted
> and bandages their wounds.
> He counts the stars
> and calls them all by name.
> Psalm 147:3-4

We can walk in the fullness of God because He never lacks or diminishes in power, and He'll never change His mind about us. He wants us to acknowledge our lament, which is a holy exercise, vastly different from self-pity. Then He helps us find that sweet spot of remembrance and expectancy.

So I lamented. I laid my burdens at Jesus' feet and pressed further to know His heart. I asked Him to help me remember my history with Him. I remembered the sacred prayer gathering with my girlfriends. God was in our midst.

I looked back and recalled all the ways my son and my precious daughter-in-law have sought God because of their heartbreak with infertility. I

> We can walk in the fullness of God because He never lacks or diminishes in power, and He'll never change His mind about us.

surveyed my history with my Father and rehearsed the countless ways God has empowered me to do good work despite not feeling well. I marveled that though my ears rang, I could still hear the voice of my King. I pondered the words I read from Scripture this morning.

> **Let all those who take refuge and put their trust in You rejoice; let them ever sing and shout for joy, because You make a covering over them and defend them; let those also who love Your name be joyful in You and be in high spirits.**
> Psalm 5:11 AMPC

How do we walk in the fullness of God's love while we wait for the fulfillment of His promises? We remember what we possess in Christ Jesus *right now*. We revel in the assurance that we have an eternity with God, and no demon in hell can snatch it from us. We realize that while we walk this earth, we live in the now and the not yet. We lean hard on the Lord. We envision God's intervention. We get a picture of what healing might look like for us. We rejoice in God's goodness, and we keep walking. And we keep believing.

God is good.
His promises are true.
And He will always make a way for me.

*Because God is faithful, I will keep
walking and keep believing.*

Psalm 23:1-3; Psalm 30:1-5

day 16

Yours Is a Great Story

Mighty God in heaven, by faith—with an inherent trust and enduring confidence in Your power, wisdom, and goodness—I live and breathe in Your presence, trusting You to work out Your plans and purposes for me, my family, and the world. The end of this story is far more glorious than its beginning. I know that for sure because You are the author and finisher of my faith. Help me live fully into the story You're writing with my life. Thank You, Lord. Amen.

God cares very much about our beginnings and our endings. That's why the Enemy goes to such great lengths to sabotage both. I read a report recently about how one nation plans to pass a bill to end a young person's life if they so choose (assisted suicide) without parental consent.[20] I gasped when I read it. Yet given our times, I shouldn't be so surprised.

We serve the God of hope. We stand firmly against the Enemy of our souls, the thief of all hope. He works tirelessly to rob us of our belief and confidence in God. Our Enemy *hopes* we'll convince ourselves that we have no reason for faith, hope, or love—that none of it matters or makes a difference. Why? Because then we'll make hope-deprived decisions.

The suicide rate is what it is because our Enemy is good at what he does.[21] He wants us to put a period at the end of a sentence God is still writing. He baits us into making permanent decisions over temporary problems. He skillfully tempts us to draw premature conclusions when our story is far from over.

What's the antidote? What's the answer?

We lean into God's grace and suspend judgment when we're tempted to draw conclusions. We take deep breaths and pray for restraint when our flesh screams for an answer, even if it's the wrong one. Every story has its heartbreaks, losses, and delays. Most people go through life bleeding under their armor. We get battered and bruised on occasion. Make no mistake; we live behind enemy lines.

But we serve the God of the breakthrough. And we see His goodness— every day—*in the land of the living.* God knows we need glimpses of His glory to keep going. Remember what the psalmist said?

> *I would have despaired* had I not believed that I
> would see the goodness of the LORD
> in the land of the living.
> Psalm 27:13 AMP

Any and every breakthrough is a gift from our good Father. But how glorious are the victories snatched out of the jaws of defeat. How mighty are the breakthroughs after you've endured an intense battle! Our battle scars testify to our battle strength.

Looking back over my story, I can point to chapters where I might have ended it all, if given an easy choice. But every time I fell facedown before God and begged for mercy, I'd hear that faint whisper, *It's not over yet. Just wait until You see what I have up My sleeve. Dare to trust Me, not your feelings. I love you, My daughter, but you're wrong about your conclusions. When I look at you, I see My image. When I step back and look at your story, I see My glory. Do not let the Enemy take you out! You don't know what you don't know. Here's where you trust Me!*

I don't know what you're walking through, and I don't know what breaks your heart. But this I *do* know: God's not finished with you yet. Your story is going to bring Him great glory.

You've got more living, giving, praying, and believing to do. The land ahead is a good land. Yes, there'll be giants to defeat, but you have the God of Angel Armies actively involved in your story!

God's not finished with you yet. Your story is going to bring Him great glory.

Because of Jesus,
I am bold, called, and courageous.

God is for me, with me, and all around me.
It's impossible for Him to fail me!
I will see His goodness in the land of the living.

BRAIN RETRAIN

I will not die but live and declare the works of the Lord.[22]

FURTHER STUDY

Psalm 103:1-5; Psalm 118:17

MY RESPONSE

day 17

Your Body Is a Gift

Good, good Father, I thank You for the gift of my body. Thank You for eyes to see, ears to hear, and a heart to do Your will. Thank You for the systems within me that work because You created me to live, move, and flourish in You. Forgive me for the countless times I've cursed myself unknowingly. My body is the temple of the Holy Spirit. I carry Your treasure in this earthen vessel, and I refuse to degrade myself because of the world's shallow standards. I'm Your masterpiece. I bear Your image. I am fearfully and wonderfully made.[23] I wholeheartedly embrace these truths today! Amen.

We have a large mirror in our exercise room. As a former fitness professional, I know how easy it is to fall out of form when exercising. You can hurt yourself if you lift weights incorrectly or do squats without the proper technique. You may have years of practice doing things right, but when

you're tired, overworked, or on the verge of a cold, you'll sacrifice your form without realizing it. The same is true in life. We carry ourselves differently when we're tired, disappointed, or hurt.

The other day I picked up some weights, faced the mirror, and prepared to do dead lifts when the Lord's voice thundered through my heart, *Look in the mirror and declare out loud, "I love my body. I'm grateful for my body."* I was instantly uncomfortable. I looked in the mirror, and my mind flooded with memories of times I cursed myself because I felt my body betrayed me, let me down, and was too weak to fight the most basic environmental toxins. I thought of the countless times I've embarrassingly needed special accommodations because moldy buildings cause my head to go numb and my cognitive abilities to dull. It frustrates me more than I can express. My personality bent is to focus on and care for others. But my physical challenges require others to make accommodations for me.

So there I stood, profoundly convicted for the thoughts I'd entertained without realizing their impact on my health and my Father's heart. *Lord, forgive me.* I looked in the mirror and said, "Lord, thank You for such a gift. I do love my body." I instantly realized I was blazing new trails in my brain.

This was new territory, and it was what my soul needed, so I continued praying out loud: "Father, forgive me for the countless times I've cursed my body for betraying me. My body is the temple of the Holy Spirit. There's more right with me than wrong with me. Your Spirit is alive in me! I love myself because You love me. I'm getting stronger and healthier every day!"

Berating my body had become a well-worn, destructive path in my brain, and not without consequence. Deciding to take a new direction and think redemptive thoughts literally changed my whole day.

Maybe your struggle isn't your health; it's your size, your skin, or your sense of identity. Our struggles reveal our thought processes. What comes to mind when you look in the mirror? Can you imagine God miraculously redeeming your view of yourself?

The world has made an idol out of a woman's body. The Enemy is always about the counterfeit. He's always looking to diminish God's glorious handiwork. He also hopes we'll take the bait of his counterfeit work and run to another unhealthy extreme. As Christians, we don't want to idolize our bodies, so we often end up berating our bodies—as if it's somehow noble to belittle God's handiwork. The opposite of idolatry isn't cursing or belittling; it's blessing and gratitude. Read this sobering passage from Scripture.

> What sorrow awaits those who argue with their
> Creator.
> Does a clay pot argue with its maker?
> Does the clay dispute with the one who shapes it,
> saying,
> "Stop, you're doing it wrong!"
> Does the pot exclaim,
> "How clumsy can you be?"
> Isaiah 45:9

You are a masterpiece, created by God Himself for the purpose of glorious works on the earth today. You bear His image, carry His name, and live for His glory. God smiles when He thinks of you, shouts songs of joy over you, and lovingly covers you in the shadow of His wings.

Ask your Creator to show you if you've maligned yourself in a way that has dishonored you and Him. God wants us to live loved, called, and confident, not because of how we look but because of the One who is fully alive inside us. We carry the treasure of the One who treasures us.

FAITH DECLARATION

I love myself because God loves me!
I'm getting stronger and healthier every day.
I live with joy and walk in power
because Jesus is alive in me!

BRAIN RETRAIN

I love my body. It's a gift from God.

FURTHER STUDY

Ephesians 2:10; 1 Corinthians 6:19

day 18

Rightly Placed Trust

Faithful Father, I'm growing and learning to trust You in the way You deserve. You are faithful, patient, kind, and true. You know the journey I've walked. You know it's been hard at times. And You're fully intent on healing, restoring, and redeeming every part of my story. Help me imagine Your smile, enjoy Your presence, and count on Your goodness. Teach me to rest in You while I stand firmly against the Enemy's lies. You've established a path of peace for me. Help me walk in it. Amen.

When you've walked through a lot of heartbreak, loss, and disappointment, your default setting will naturally be one of bracing for impact to minimize collateral damage. Yet it's impossible to dream, create, and wonder about miracles when you're just hoping to avoid the next firestorm. And while Jesus said we'd endure trials and hardships, He wants to grow our

capacity to trust His love—a love that promises to work *everything* together for our good and for God's glory (Romans 8:28).

I've spent the past two years immersing myself in thoughts of God's goodness, and I marvel at the difference it has made. Still, muscle memory exists within me. When specific symptoms flare or an old heartbreak resurfaces, I instinctively move toward self-preservation. My unedited reaction is to wonder if God will allow yet another crisis in my life.

A sure sign that we need deeper layers of healing is when we blame God for the pain the Enemy orchestrated and that Jesus died to redeem.

God wired us for love, healing, and flourishing. Yet these things are squashed within us when we confuse our sources of life and death.

Our Enemy is the source of death, lies, cancer cells, diminishing remarks, demoralizing thoughts, and every injustice on planet Earth. He sows bad seeds that create weeds to choke out the life that's bursting all around us. The devil works tirelessly to craft a believable narrative so we'll embrace a lie that weakens us instead of the truth that strengthens us.

Since he can't literally separate us from God's love, he'll make us question that very love. Love that saves, heals, reveals, and restores us from the inside out.

God is our Creator, an unrivaled force of power and majesty and might. And He is kind, patient, loving, and fiercely angry when His children suffer. He sent His Son, Jesus, to die for us, making a way for our eternal security. He's the source of life, breath, healing, and hope. He's the dream giver, promise maker, holy defender. He gives rest to the weary and strength to the powerless (Isaiah 40:29–31). He loves our faith, and He moves when we pray. How blessed are we?

The God Who made the world and everything in it is the Lord of heaven and earth. He does not live in buildings made by hands. . . .

It is in Him that we live and move and keep on living. Some of your own men have written, "We are God's children."

Acts 17:24, 28 NLV

It takes practice to redirect our thoughts when we catch ourselves accusing God of things the Enemy has orchestrated. The sooner we learn to rest in God and enjoy His presence, the sooner we'll discern His ways and realize how they differ from our Enemy's intentions toward us. If we dare to trust God more and more in the days ahead, our bodies and souls will learn to rest, and perhaps, start to heal. Yes, trials will come. But the truth is, we'll emerge stronger, wiser, and fiercer when we stay in step with Jesus and remember who our real Enemy is.

If God is *for us*, who can stand against us (Romans 8:31)?

> The sooner we learn to rest in God and enjoy His presence, the sooner we'll discern His ways and realize how they differ from our Enemy's intentions toward us.

FAITH DECLARATION

I believe in the miracle-working power of almighty God.
I'm filled with His Spirit.
I'm empowered by His love.
I'm being restored from the inside out every day.

I'm destined for wholeness and freedom.

———

Proverbs 3:5-6; Isaiah 26:3-4

MY RESPONSE

day 19

God Heals in Time

Gracious Father, I want to know You for who You are. I confess that sometimes I view You through the lens of my experience rather than Your Word. Help me to know You more. Bind my heart to Yours. Help my body, mind, and soul to find their home in You. Though I don't see the future, You do. Though I don't know how You'll intervene, I know You're working. Though I don't know what You'll say, I know You'll speak. There's a lot I don't know, but this I do know: You are good, Your promises are true, and You will always, always make a way for me. Thank You, Lord. Amen.

The subject of supernatural healing is a hotly debated topic in Christian circles. Some say that the day of miracles has passed until we see our Savior face-to-face. I say this with great love and humility, but I see things differently. Jesus is the same yesterday, today, and forever (Hebrews 13:8).

My son received a medical miracle when God instantly healed his back from a severe disc blowout. After months of excruciating pain and limited mobility, Jordan came home from youth group one night, miraculously healed. He ran drills with the football team the next day. For every person who pretends to have received a miracle for show, thousands have truly encountered God and received the healing they desperately needed.

Even so, physical restoration hasn't gone that way for me. It has come in layers, slowly and oftentimes painfully. So much of my fear, anxiety, and trauma were baked in with the illness that God, in His wisdom, has healed me in phases, one layer at a time. To me, though, my story is no less miraculous.

Even though I've seen God's goodness in the land of the living, and I fear God and honor His Word, I want my theology grounded in Scripture, not my experiences. That said, there *is* a solid case for healing in Scripture. Countless passages speak to God's power and Jesus' compassion to heal, making it a leap to conclude that our Lord refuses to intervene in our day.

Why, then, do godly people today get sick and die? Why does God heal some and not others? I've wrestled with these questions for more hours than I can count. I'm not willing to say that A + B *always* = C. I've met hundreds, if not thousands, of women who felt tossed aside because they thought they didn't have the faith to be healed. It's bad enough when you suffer from a chronic issue, but when you're blamed for your affliction? It's not right. Jesus met the sufferer with compassion, not with judgment.

Yet on the other side of this argument are many who've found their identity in their affliction. They're more comfortable with their sickness than with contending for something more. I'm not sure who said it first,

but I've heard that many consider a known captivity more comfortable than an unknown freedom. I've wondered, *How might freedom change me? What would I do with the extra bandwidth?* The thought has made me tremble at times.

Still, I can't *not* contend for my physical healing. I've seen too much evidence in Scripture to surrender to this illness. There's a big difference between surrendering to your circumstances and surrendering to God in your circumstances.

Our Father doesn't make His children sick to bring glory to Himself. What good father would do that? But for some reason that I cannot understand, He also allows some of His cherished, devoted children to die, afflicted with their disease. What are we to make of this?

Yet think of those who died of their affliction with faith in their hearts. Can you imagine their reunion with Jesus? The glory of their transformed body? Do you think they're still groaning over what they suffered on earth? Death has been swallowed up by life, victory, and renewal!

> **I'm sure of this: the sufferings we endure now are not even worth comparing to the glory that is coming and will be revealed in us.**
> **Romans 8:18 THE VOICE**

I've decided I'm comfortable with the mysteries of God. I know enough about Him to believe that He is good. I know that my faith has changed

There's a big difference between surrendering to your circumstances and surrendering to God in your circumstances.

me and has tethered my heart to His. Faith matters to God. Believing Him for what we cannot see is precious in His sight.

Because of Jesus' shed blood and victory on the cross, every believer can confidently say, "God is healing me, and one day I'll be symptom-free. I don't know how. I don't know when. But I know that He will heal me. Whether in this life or the next, I will walk in renewed vitality!"

There's not one instance in the New Testament when Jesus told someone He afflicted them to teach them a lesson. Everywhere He went, Jesus healed the sick. And those in Scripture who believed He'd do what He promised? We're still talking about them today.

FAITH DECLARATION

Jesus saves and Jesus heals;
I am His and He is mine.
One day I'll be fully healed and whole.
I believe and receive all He won for me.

BRAIN RETRAIN

By God's grace, I am healing. I am being restored.

FURTHER STUDY

Psalm 103:1-5; 3 John v. 2

day 20

Make Space for Hope

Lord God, hope sometimes feels so costly, yet our hearts can't live without it! You are the God of all hope and the giver of all good gifts. Let hope arise within me on this day! Not wishful thinking or positive thoughts; I want redemptive hope—a pure, confident assurance that You are up to something good and soon my eyes will see it. Heal the places in my story where disappointment still lives. Help me plant fresh seeds of hope, knowing the harvest will come in due time. Thank You, Lord. Amen.

We were out to lunch recently with our son Jake and his precious wife, Lizzie. They're the ones who've battled infertility for many years. I've watched them graciously play with nephews and nieces on the floor and enter into family times with a heart hospitality that's left me breathless. I've watched holidays come and go with no signs of a breakthrough. Still,

they've stayed engaged in their relationships. They buy thoughtful gifts for birthdays and Christmases. They pray for the rest of us when we walk through hard times.

I've marveled as I've watched them. I've cried out to God more times than I can count. I know He hears us, but this has been heartbreakingly painful.

They've tried hormones, IUI, and IVF and are now walking through the process of something called snowflake adoption. Over lunch, I told Jake, "I'm praying for an acceleration of your paperwork. That you'll be matched with a baby sooner than you expect." Jake's eyes welled with tears, and he reached for my arm. "Mom! Don't pray that way for me. That's not what I want. That's not helpful right now. I don't need this process to speed up. I need my heart to heal. Our hopes have been dashed so many times; I need a heart that has space for hope." Ugh. I choked back the tears and said, "Of course, honey. That makes so much sense. That's exactly how I'll pray."

I asked Jake and Lizzie if I could share this part of their story, and he said, "One of the ways we can partner with God for the renewal of all things is to use our story to help others." I love that boy.

I can think of countless times when I was willing to bypass hope and just wanted relief. More than relief, God is after the full redemption of our story. We just want a break, but God is after a break*through*. Jake's prayerful plea was bursting with wisdom. It's not enough just to get what we want when we want it. God wants life to spring up in every aspect of our story. He wants our hearts to have lots of space for hope.

> We just want a break, but God is after a breakthrough.

God knows our end from our beginning. He's written out all our days before we've lived even one. He knows the way we take, and He knows we'll come through our trials as gold, as ones purified by the fire.

If hope feels too expensive for you, don't despair. Just whisper a prayer to the One who loves you, holds you, and will never let you go. He is your faithful God, and He knows what you need and even what you strongly desire. His plans for you are good. Really, wonderfully good.

> "I know the plans and thoughts that I have for you," says the LORD, "plans for peace and well-being and not for disaster, to give you a future and a hope."
> Jeremiah 29:11 AMP

The word translated as "well-being" in the verse above means peace in relationships with others and God, soul prosperity, health, safety, and wholeness.[24]

Let your heart rest in His goodness. Dare to trust Him with the most vulnerable parts of your story. He's tender with your weakness and compassionate with your hurts. He'll surround you with His favor as with a shield. You can trust Him. Let hope *arise*.

FAITH DECLARATION

Jesus is my Lord.
He holds my heart.
He gives me hope.

He renews my strength.
He is always good to me.

BRAIN RETRAIN

Goodness is on its way to me.

FURTHER STUDY

Romans 15:13; Hebrews 11:1

MY RESPONSE

day 21

For All He's Prevented

Mighty God and Father, You are very protective of me. You love me. You watch over me. And Your Spirit guides me into all truth. I have everything I need in You. Thank You for the countless ways You've intervened in my life. For all You've provided and all You've prevented. My finite mind cannot comprehend Your goodness, especially Your goodness and kindness to me. But I will spend time today pondering all You've done for me, all You've won for me, and all the fears that never materialized because You protected and directed me. I worship You, Lord. Amen.

In my book *Fully Alive*, I wrote about a time when I was in my bathroom getting ready for work. Surges of numbness and dizziness overtook me, and spasms grabbed me by the throat. The Enemy spewed his threats in

my ear, and anxiety threatened to swallow me whole. I cried out to God in fear and desperation. My cry reached His ears.

God spoke to my heart that day in a way that changed me. I'm praying it will help us find perspective today. Deep in my soul, I believed the lie that the Enemy could get to me anytime, anywhere. It felt true, and there seemed to be enough evidence to prove it was true.

When I cried out to God in the bathroom, His voice thundered in my ear:

Susie, it's not true. There is a limit to what I'll allow in your life. Someday you'll see not only how richly I've provided for you but also how much I've prevented because I love you and I know your limits. I'm not going to let you lose, but I have to let you fight. You've lived your whole life waiting for the other shoe to drop, for the next trauma to happen. It's not good for your heart or your soul to live like that. We don't run from our fears; we turn around and face them. Yes, it feels like the Enemy has you by the neck, but soon enough your foot will be on his neck.[25] Stand and fight. I promise, you will win this battle.[26]

Since that morning, I've spent many hours thanking God for all that *didn't* happen to me. The list is endless. I'd spent years framing my fears by imagining worse fears. Yet when I started to thank God for all He's prevented, my heart bloomed before Him like a flower. Suddenly I realized how kind and meticulous He'd been with my weaknesses and limits. Whereas before I felt constantly threatened, now I feel continually loved.

Someone once said that if we all put our troubles on the table, most of us would take our own troubles back because those are the ones we're graced to handle. And would you trade your blessings? The good parts of your life?

Consider today the ways God's love has covered your multitude of sins (1 Peter 4:8). How many wrong judgments or unkind assessments have you made that never came back to bite you in the . . . well, you know? How many of your more unflattering moments were covered by the blood of Jesus, forgiven and cleansed, and only you and God know about them? Yes, there are consequences for our sins, and God—in His divine wisdom—knows when to cover us and when to correct us publicly. He never turns a blind eye to our sins but always lives to make intercession for us (Hebrews 7:25).

> Do you want your day to turn for the better? Spend time thanking God for all the tragedies that never happened to you.

Do you want your day to turn for the better? Spend time thanking God for all the tragedies that never happened to you. Praise Him for the countless ways His mercies covered you and didn't expose you. Thank Him for the times your fears didn't materialize. And thank Him that the Enemy is utterly unable to snatch you from His hand. My goodness, God is good. Amen.

Because of Jesus,
God has lavished His goodness on me.
He has poured out His Spirit upon me.
He has cleansed and forgiven me.
My God is always with me.

BRAIN RETRAIN

God is my refuge and my safest place.

FURTHER STUDY

Psalm 18:1–3; Psalm 46

MY RESPONSE

day 22

Tell Yourself a Better Story

Precious Father, You are writing a beautiful story with my life. Help me hear the song You're singing over me even now. Forgive me when my words, phrases, and complaints are out of sync with Your will and Your ways. When my problems feel more significant than Your promises, help me tell myself a better story. The truth is, You are good, Your promises are true, and You will always make a way for me. I will declare Your goodness over my life today! Amen.

There's no scientific study to back this up (that I know of), but I believe one of the leading causes of exhaustion and procrastination is the story we tell ourselves. I marvel at how many times I've caught myself talking myself right into a funk. Maybe I didn't sleep well the night before. Even so, I got

enough sleep to function. I started the day rehearsing *I'm exhausted* and carried it throughout the day. I'm sure you can imagine what kind of day I had.

One day I realized what I was doing and changed the story. I took inventory of the energy and grace *I did* possess and went after my day with gusto. It turned out to be a great day, and surprisingly, when I quit saying I was exhausted, I realized I actually felt pretty good.

In other seasons, the opposition was far more intense than a poor night's sleep. Even so, I noticed lethargy and fatigue setting in. I wasn't motivated to tackle my basic tasks. Things piled up, and suddenly I felt overwhelmed. It's hard to face piles of work when you're exhausted, right? But when I retraced my steps, my thoughts, and the story I'd been telling myself, I saw it clear as day: I held my problems closer than His promises. I needed to edit my narrative.

What had I been telling myself up to this point? *I'm exhausted. This is too much. I hate these symptoms. Will they ever end? My inbox is impossible. I'm stuck. I'll never get ahead of this task list. Will I ever have energy again?*

My goodness, it's embarrassing to admit such defeatist thinking. But that's where I was when exhaustion overtook me.

Then I decided to pull God's promises closer than my problems, and my confessions started to sound like, *I am strong and mighty in the Lord! I am energized to do all He's given me to do! I get to do the work of the Lord, and I will do it with all my heart. I'll do my best and trust Him with the rest. It's the Lord who fulfills His purposes for me.*

I don't have words to describe the difference it made when I lined up my script with God's story for me.

How about you? Are you tired and weary? First, run to Jesus. Remember His invitation?

> Jesus said, "Come to me, all of you who are weary and carry heavy burdens, and I will give you rest. Take my yoke upon you. Let me teach you, because I am humble and gentle at heart, and you will find rest for your souls. For my yoke is easy to bear, and the burden I give you is light."
> Matthew 11:28-30

Trust Jesus for the energy and the rest you need. And ask Him to show you a better way to tell your story, a better way to speak about your life when the waves crash against you. Pull His promises closer than your problems. In due time, you'll be walking on the water with Him.

> Ask Him to show you a better way to tell your story, a better way to speak about your life when the waves crash against you.

FAITH DECLARATION

Because of Jesus,
I am strong in the Lord and in the power of His might!
I'm energized and equipped to accomplish
all He's entrusted to me.
I sleep soundly, rest deeply, and wake
refreshed because God is with me!

I live victoriously in the epic story God is writing in my life.

Psalm 43:5; 2 Corinthians 4:13

MY RESPONSE

day 23

Relax; He's Leading You

Lord God Almighty, I don't want to miss a thing! Heighten my sensitivity to Your voice. Awaken my heart until it beats in rhythm with Yours. Show me the places in me where I'm too easily distracted and where I consistently slip into double-mindedness. I want clarity of heart and deep discernment for the things of God. And I want to learn to enjoy the journey, trusting that Your peace will guard and guide me. Thank You, Lord, for Your tender care for me. Amen.

Many years ago, Kev and I served as volunteer youth pastors. We sat in the crowd as the high school graduates lined up onstage at church. One by one, the pastor asked the students what they planned to do after graduation. Some of their answers included attending college, going on the mission field, and helping with their family's business. One student, whom we loved dearly (and was as chill as they come), smiled, paused, and shrugged

his shoulders. He confidently answered, "You know? I don't know. But I'm not worried about it. I'm sure it'll work out."

Kev's eyebrows arched, and he peeked at me. We both chuckled quietly. I knew what he was thinking. Even though our high-achieving students had plans, they were worried they'd make a wrong decision. This dear one didn't plan and didn't worry about it. In this case, some concern would have been wise.

Often, the highly sensitive, earnest follower of Christ falls into the trap of overanalyzing every step and scrutinizing whether they're following the path of God's highest and best will. I'm one of those people. But in recent years, God has highlighted an aspect of our relationship I'd missed up until that point. One day, I was on a deadline, trying to remember a story I wanted to convey correctly. But I couldn't find the journal that held that story.

Meanwhile, I was also spring cleaning and getting rid of things I didn't need. My head was in my cleaning project when I stumbled upon a stack of journals. I randomly picked up one of the journals, flipped it open, and found the story I'd been looking for. I faintly heard His whisper across my heart, *I'm leading you even when you're unaware.* Peace flooded my soul.

Since that day, God has highlighted moments when He's guarded and guided me in the way I should go while I randomly went about my day. God's loving attention to detail continually brings rest to my soul.

When we treasure Jesus, sincerely walk in His way, and deeply value His input, He'll lead us with tender care and a watchful eye. In his brilliant book *A Shepherd Looks at the 23rd Psalm*, Phillip Keller wrote:

If He is the Good Shepherd we can rest assured that He knows what He is doing. This in and of itself should be sufficient to continually refresh and restore my soul. I know of nothing which so quiets and enlivens my own spiritual life as the knowledge that God knows what He is doing with me![27]

Read about the journey of God's chosen people in the Old Testament, and you'll see a people who first rebelled by refusing to listen to God. You can listen only to one voice at a time. They no longer valued God's input. That very act turned their hearts toward other sources, which hardened them in the process.

When we treasure Jesus, sincerely walk in His way, and deeply value His input, He'll lead us with tender care and a watchful eye.

The current of culture rages strong. This is not the time for a "don't worry, be happy" mindset. If we're not earnestly seeking God, we *should* be concerned. But if we love Him, want to please Him, and give time and space to hear from Him, we can go on our way joyfully without overanalyzing every step. In fact, we bring great joy to God's heart when we trust Him with our hearts.

If you have a sensitive spirit and follow wholeheartedly after the one true God, take a deep breath and exhale. Trust that His Spirit is alive in you. Let His peace guard and guide you. He's leading you, even when you're unaware.

Don't worry about anything; instead, pray about everything. Tell God what you need and thank him for all he has done. Then

you will experience God's peace, which exceeds anything we can understand. His peace will guard your hearts and minds as you live in Christ Jesus.

Philippians 4:6-7

Because the Lord is my shepherd,
I have all I need.
He sees me; He leads me.
He fills me and frees me.
My heart rejoices in Him!

My Good Shepherd leads, and I follow.

Psalm 23; Psalm 139:5

day 24

He Guards and He Guides

Precious Father, my soul finds rest in You alone. My salvation comes from You. If I can trust You with my eternity, I can trust You with the nuanced areas of my life. You're always moving; may I continually follow. You're always speaking; may I continually listen. I say this by faith: I am so in tune with Your presence and influence in my life that even at night, my heart instructs me.[28] I'm earnestly following You, and You're faithfully leading me. Thank You, Lord. Amen.

One night I had a dream that troubled me. I don't often dream. And most of my dreams are a blurred compilation of thoughts and images from the day before. But occasionally, I have a vivid dream that viscerally impacts me. I wake up knowing that God wants my attention. I'll hold the details of this dream because it's too personal and private to share. But I will say that it painted an exaggerated picture for Kev and me of what could happen

to us if we don't continue to seek God earnestly and stay in step with each other.

When I first woke up, my heart was troubled. But once Kev and I processed the dream with a friend and prayerfully sought God, we suddenly felt overcome by God's love and His desire to keep us several steps ahead of the Enemy. God gave us a clear strategy on how to draw closer together, how not to get overextended in our commitments, and definitely how not to be overconfident in areas we've built guardrails around. Just because we've never fallen in specific ways doesn't mean we never will. This dream put a fresh fear of God in us and gave us a renewed sense of God's great love for us and intimate involvement in our lives.

The Enemy doesn't rest, and he's always on mission to destroy everything good and beautiful in our lives. He loves it when we gain a false sense of security or feel so sure of our strengths that we neglect to heed God's warnings. There's a big difference between presuming upon God and humbly relying on Him. Pride presumes, expects, and feels entitled to things regardless of actions or attitudes.

> **Pride goes before destruction,**
> **and haughtiness before a fall.**
> **Proverbs 16:18**

Reliance, by its very definition, involves *vulnerability* because we've shifted our weight, and we're leaning on the One who is stronger and mightier than we. Scripture is packed with verses that remind us how

blessed we are when we trust in God. Imagine walking so intimately with the Lord by day that your heart downloads wisdom even at night.

I've prayed this passage over our lives for years:

> **I will bless the LORD who guides me;**
> **even at night my heart instructs me.**
> **I know the LORD is always with me.**
> **I will not be shaken, for he is right beside me.**
> Psalm 16:7-8

The word translated as "heart" in this verse speaks of our inner parts (our soul, our gut, our emotions; the place where our will, feelings, and thoughts collide). And the word translated as "instruct" means to discipline, chasten, and correct.[29]

Sometimes the noise of life gets so loud by day that God uses the night hours to speak to our hearts. May you be quick to listen humbly, quick to respond, and quick to make the necessary adjustments. God *wants* you to flourish. His nearness is for your good.

> Sometimes the noise of life gets so loud by day that God uses the night hours to speak to our hearts.

Sometimes the noise of life gets so loud by day that God uses the night hours to speak to our hearts.

FAITH DECLARATION

Because I walk intimately with Jesus,
He speaks clearly to me, even in the night hours.

I listen for His voice and do what He says.
He guards and guides me as the apple of His eye.

God guards and guides me, even at night.

Psalm 19:1-2; John 10:27-30

day 25

The Valleys Will Be Filled

Lord God Almighty, You don't miss a thing! You know about every loss, hurt, and disappointment in my life. You're aware of all the ways the Enemy has stolen from me. You are mighty to save. You are my Redeemer, Restorer, and the one who revives my soul. Thank You, Lord. I refuse to draw conclusions based on temporary trials. I know You're good, and You're not finished with my story yet. My valleys (my places of lack) will soon become pools of blessing. You continually fill my life back up again. I love You, Lord. Thank You. Amen.

———

Recently, my husband and I did a live broadcast on one of our social media platforms to pray for the sick and hurting. The next day, both of our accounts were hacked. The hackers removed us as admins and took over the page. They changed Kev's picture to someone else. They used his

page to access my ministry account, on which they posted gory videos, to everyone's shock. If that wasn't enough, they also made Kev an admin to a digital software company and used our accounts to pay for an ad.

In a matter of moments, people sent us messages complaining and asking what happened to our social media accounts. One woman, trying to help, reported the page and accidentally clicked the box that suggested my page was bullying her. She felt horrible and emailed me to apologize for adding to the problem.

During this same season, we counted on a portion of our income that didn't materialize. We had to push pause on a ministry initiative that would have been funded by that money.

I've been thinking about Jesus' words in John 10:10 (AMPC):

> "The thief comes only in order to steal and kill and destroy. I came that they may have *and* enjoy life, and have it in abundance (to the full, till it overflows)."

Our Enemy steals from us to kill our joy and destroy our vision. But whenever the devil makes a move, we must know that God already has a plan. As I often say, for the believer, our setbacks are always only temporary. Yesterday during church, I worshiped with all my heart. Yes, I'd allowed these stresses to get to me in recent days, but at that moment, I realized I lacked no good thing. I focused on God's goodness, His love, and His power to save. In my heart, I knew Jesus would advocate for us in ways we couldn't advocate for ourselves.

At that moment, the Lord thundered this wisdom in my heart: *Susie, these are strategic, temporary losses. I've allowed them to teach and train you, to prepare you for the days ahead. Trust Me fully in this place. These valleys will be filled. Don't whine. Don't complain. And don't just bide your time, hoping things will work out. Speak to the valleys and command them to be filled with pools of blessing!*[30]

Instantly, faith surged throughout my whole being. I wasn't helpless in this battle. God's Word was alive within me. His promises and power were a shield around me. I had an audience with the King. He heard my cry and gave me the strategy I needed.

One of the ways you know you've heard from God is when wisdom and life spring up within you, and you're energized on the very battlefield where the Enemy has terrorized you.

I prayed blessings on those who stole from us. I thanked God that no weapon formed against us will prosper (Isaiah 54:17). I pictured the valleys of lack and spoke with fiery faith, "Be filled to overflowing with the provision of God! Nothing and no one can stop God's goodness!"

You've undoubtedly experienced the Enemy's thievery in your own life. Yet God, in His wisdom, plans to redeem and restore what's been stolen. We give the Enemy too much airtime when we focus on the person or circumstance that caused a loss in our lives. Our restoration comes from God alone. Take power away from your Enemy by looking to the Lord and His strength. Picture your losses as valleys just waiting to be filled. Step back and imagine the amazing ways God might come through for you.

> Picture your losses as valleys just waiting to be filled.

Spend some time in Psalm 84 when you can. Here's my paraphrase of verses 5–7:

We're filled with joy because our strength comes from the Lord. We've set our minds on our eternal pilgrimage to the Holy City. When we walk through the valley of weeping, we make it a place of refreshing springs because we are there and God is with us. We will continue to grow stronger on this journey until we see Jesus face-to-face. Hallelujah!

FAITH DECLARATION

Because of Jesus,
no weapon formed against me will prosper!
God is my Fortress and my Defender.
I have everything I need because I have Jesus.

BRAIN RETRAIN

My valleys will be filled with pools of blessing.

FURTHER STUDY

Psalm 84; Joel 2:25

day 26

Look for Signs, Not Symptoms

Lord, I lift my chin upward this day. Open my eyes to the wonders of Your ways in and around me. Forgive me for allowing my symptoms and my stresses to take my thoughts down a path that's life-taking, not life-giving. I refuse to think like a sick or stressed person. I'm a blessed person! I have You! Teach me to think Your thoughts so every cell in my body aligns with Your wisdom and ways. Jesus defeated sin, sickness, and the powers of death on the cross. I believe and receive all He won for me. In Jesus' name I pray, amen.

When I was a young mom battling my first years of Lyme disease, I begged God to heal me. He seemed silent. Scripture felt dry. My body betrayed me. There seemed to be no way around this wilderness, only through it.

One day, the Lord broke His silence and whispered to my heart, *Susie,*

I could heal you today, but you'd lose it tomorrow. You think like a sick person. You don't have the infrastructure for healing. Change your thinking, and you'll learn to tap into My strength.

He was right. Whenever my face went numb, a dizzy spell spun me around, or neurological symptoms surged through my body, my thoughts took the fear train to the next exit of worst-case scenarios. I had a flimsy infrastructure. Nobody was controlling my thought patterns. Those were mine to own. Yes, my symptoms were concerning, but I needed to start thinking like a healthy person. And so I did. I thanked God for what I did have—for my bones, muscles, and joints. I thanked Him for my senses—I could see, hear, taste, touch, and smell.

What a gift! My heart beat in rhythm with life, allowing me to be present for my boys. I soon realized there was more right with me than wrong with me. I meditated on God's Word and personalized His promises. There's such life in the Word!

This is not to say you should ignore your anxiety, depression, or illness; in fact, seek medical help if necessary. But it *is* to say that you'll better discern your strategy to navigate your trial when you align your thoughts with God's thoughts toward you.

> Don't copy the behavior and customs of this world, but let God transform you into a new person by changing the way you think. Then you will learn to know God's will for you, which is good and pleasing and perfect.
>
> **Romans 12:2**

It's true. Our bodies are earthen vessels. They sometimes fail us. And it's also true that we live in a world full of stresses that pull our attention toward them. But truer still is the precious promise of God's presence. He's *always* with us. He cares for us.

Daily, we're given countless opportunities to accuse God or trust Him. Suppose we allow our stress or symptoms to occupy our thoughts. In that case, we'll train our brains to look for and be sensitive to the slightest negative information that reinforces our cultivated bias.

Conversely, when we immerse ourselves in thoughts of God's provision, His attention to detail, and His continual care for us, our brains will automatically be looking for *more evidence* of God's goodness. And, friend, it's everywhere.

Keeping a gratitude journal is a great way to redirect your thoughts to all things God. Each night, write down a few ways you noticed God's involvement in your life that day. Write out a short prayer of thanksgiving. When you develop a habit of gratitude, your brain will assist you in noticing goodness that you'd otherwise miss.

The more we train our minds and bodies to sense God's goodness, the sturdier our steps will become. And when the symptoms and stresses come—and they will—we'll have a backlog of experience that proves God's faithfulness. We'll learn to view our everyday stresses as temporary and even as *opportunities* to see how God will move on our behalf.

Our best life and most profound restoration

> The more we train our minds and bodies to sense God's goodness, the sturdier our steps will become.

await us when Jesus returns. But we *will* see plenty of His goodness on this side of eternity because our God is with us.

> I am confident I will see the LORD's **goodness**
> while I am here in the land of the living.
> Psalm 27:13

FAITH DECLARATION

God is good, and I am loved!
His strength works mightily within me.
I am blessed and beloved,
bold and brave!
Because Jesus is alive in me!

BRAIN RETRAIN

By God's grace, He's restoring my
soul and making me whole.

FURTHER STUDY

Psalm 18:31-36; Psalm 89:17

day 27

Redeemed Desires

Precious Father, thank You that my losses are only temporary. And my insecurities offer information on the places You want to redeem. When the Enemy comes in like a flood, You raise up a new standard within me. You show me new things to believe You for and new places for my feet. You teach me to walk in high places. You put a fresh wind in my sails. You dare me to dream with You and then to watch and see what You will do. I refuse to let my limits have the last say. You are the God of limitless power. My soul waits for You. Amen.

You know those moments when you see something or hear something that hits a nerve within you? It kind of makes your knees buckle, or at least it takes the wind out of your sails. How often does a simple social media post or update on someone's story do that to us?

When someone else's blessing stirs up pain within, it's often because

the loss is still real for us, or the lie still has power over us. My former pastor (he's retired now) used to say, "When you get stirred up, don't despair. That's just God grabbing hold of that thing, pulling it out, showing you what it is, and then saying, 'You see this? I'm about to deliver you from this thing!'" I love that. We tend to shrivel when we're poked and then wither more because we're pokable.

God doesn't fault us for our frailty. He's especially near to the brokenhearted.

Recently, I experienced three instances on the same day that jabbed a couple of unhealed places in me. It surprised me like a gut punch. I didn't see it coming. And I thought I'd already dealt with those lies. But when I looked a little deeper, I sensed a beautiful invitation from God. I realized that He *has* brought great freedom to my heart. Yet there were still some small spaces in my soul where the lies lay dormant. But God allowed them to surface. I thought about how the Enemy conditions us to believe his lies and how God trains us to walk valiantly in His truth. "What do You have for me here, Lord?" I asked.

He answered, *Redeemed desires. Your pain, when left unchecked, will pervert your motives. You'll strive for things that only temporarily satisfy you. You'll misuse your time, treasure, and talents to prove something that belongs to Jesus alone to prove. But when you respond to My invitation to heal, you'll learn to dream with Me. I'll put fresh desires within you, and you'll walk them out in a healthy, healed, and holy way. Never despair when you're stirred up. Just look up. I'm right here.*

I think we'll have triggerable places in us until Jesus returns. Not that we stay stuck in our old wounds, but we live on an increasingly troubled

planet. We may heal from one hurt and then experience pain or loss in a way we haven't before. But God is *so* committed to our redemption that He takes us on His healing path and teaches us *how to receive* what He so freely offers. May we never forget the good things He's done for us.

> Let all that I am praise the LORD;
>> with my whole heart, I will praise his holy name.
>
> Let all that I am praise the LORD;
>> may I never forget the good things he does
>>> for me.
>
> He forgives all my sins
>> and heals all my diseases.
>
> He redeems me from death
>> and crowns me with love and tender mercies.
>
> He fills my life with good things.
>> My youth is renewed like the eagle's!
>
> Psalm 103:1-5

Author and pastor Jeff Manion joined me on my radio show years ago and said something I'll never forget. He said, "Susie, we've tried to become experts at not getting hurt. But we need to become experts at learning to heal."[31]

What if we stopped living with locked elbows, always bracing for impact? What if we approached God and others with outstretched arms like Jesus did? What if we no longer feared getting hurt, because we dwell

under the wing of our Healer? What if we lived with such a confident assurance of our capacity to heal, and thus dream, that we dared to ask God for things that make our knees weak? Not in a fearful way but in an awe-inspiring way? What if our healed, healthy life inspired others to trust God with their story?

That's the God we serve. He's closer than your next breath. He looks at you with loving, tender affection. He loves you with meticulous attention. And it brings Him great joy to walk intimately with you on this journey, heal you when you need it, and promote you when you're ready for it.

What if we lived with such a confident assurance of our capacity to heal, and thus dream, that we dared to ask God for things that make our knees weak?

FAITH DECLARATION

I am loved and led by the Holy Spirit!
I dwell in the shelter of the Most High God.
I am safe and secure, healthy, and healing.
I'm free to pray big prayers because God is with me.

BRAIN RETRAIN

I dream big because I serve a big God.

Psalm 37:4; Ephesians 3:20-21

day 28

From Good to Better to Best

Good Father, thank You for Your commitment to my heart and my story. You're faithful in every generation, and You've been faithful to me. I marvel at what You've done in my life. I know I've forgotten many of the ways You've come through for me. Awaken my memories of Your faithfulness. Help me remember Your deeds from long ago. Give me eyes to see how far I've come. Show me the ground I've gained and the insights I've gleaned because of Your presence in and around me. You're taking me from strength to strength, glory to glory, shining ever brighter until the full light of day. I have every reason for joy. My sins are forgiven, my eternity is secure, and the Holy Spirit is alive in me! All because of You! Thank You, Lord! Amen.

When you walk out your everyday battles in the daily grind of life, it can seem like you never get anywhere. Where's the breakthrough? But when

you find the time to chronicle your battles and the nuanced ways God brings blessing and forward progress, you soon realize you have gained ground. Just because our battles are familiar doesn't mean they haven't transformed us! You are better for the fight.

This is not to say that growth and gain are automatics in the trials of life. In the Old Testament, the Israelites seemed determined not to grow. They tolerated two toxins that continually robbed them of their joy and transformation: entitlement and unbelief. They tried God's patience repeatedly. Yet Scripture tells us that God cared for them amid their challenges, as a Father cares for His children (Deuteronomy 1:31; Zephaniah 3:17). Sadly, they rarely noticed it. God pours His greatest gifts into His most receptive vessels.

Consider your story for a moment. You've grown in ways too many to count. You know things now you didn't know years ago. You have a firmer grasp of God's goodness and a sturdier hold on His promises. Yes, you've walked through much pain, but you're still standing! You can look back over your shoulder and recall the times God punched a hole through the clouds so you could feel the warmth of His presence. You can thank Him that even though He didn't always give you what you wanted, He always provided what you needed.

Like every epic story, yours has its twists and turns, joys and sorrows, and has taken you places you didn't see coming and wouldn't have planned for yourself. Yet your story has a happy—dare I say *astonishing*—ending.

You've likely forgotten so much of what God intimately remembers about your story. God keeps meticulous records so He can abundantly reward His children. He remembers the times you were kind when it cost you. He knows when you forgave, though you didn't want to. He saw the

many times you cheered for others while waiting for your own break-through. He's so honored by your heart to worship Him while you wait for Him. He's making a valiant warrior out of you and teaching you to *live loved*, regardless of the seasons you walk through.

Whenever you dare to believe He is good when life is hard, heaven cheers, God is glorified, and you are changed.

We can't measure our gains by the battles we face. We measure our progress by the people we're becoming. Do you love God more today than you did yesterday? Praise His name! Are you wiser to the Enemy's schemes? Thank the God of Angel Armies who has made you mighty in battle. Do you long for heaven more than ever before? Worship the One who saved you because He's preparing a place for you.

In his book *The Lord Bless You*, Terry Smith wrote:

All the force of God and history are at work making things new. New like they were in the beginning, only better because of all we have been through. You have every reason to believe that everything in your life will keep becoming more and more the way God wants it to be. I encourage you to live as if you expect to be blessed—like God blessed His people in the beginning, but even better.[32]

On your worst days and your best days, you can know your story has a beautiful ending. He wants to reward your faith! Even now, Jesus is actively and excitedly preparing for your homecoming. Oh, the treasures that await you!

> On your worst days and your best days, you can know your story has a beautiful ending.

Dear friends, we are already God's children, but he has not yet shown us what we will be like when Christ appears. But we do know that we will be like him, for we will see him as he really is.

1 John 3:2

FAITH DECLARATION

I'm not who I was.
I'm not who I will be.
But thank God, I'm free
to become all God created me to be!

BRAIN RETRAIN

By God's grace, I will shine ever brighter
until the end of time.[33]

FURTHER STUDY

Daniel 12:3; Proverbs 4:18

day 29

The Wisdom of God's Ways

Faithful Father, You are actively involved in my life, lovingly attentive to my needs, and faithfully answering my prayers. Your movement is all around me. Prayers I've prayed and long since forgotten are still in motion because You never forget. Help me live with the kind of expectancy You deserve. You're consistently engaged with my story; help me be just as engaged with Yours. Prepare my heart and life for the answers that are on their way. Stir up faith in me so I'll instantly see Your goodness when it comes. I love You, Lord. Amen.

Looking back over my decades of walking with God, I've noticed that most of His miraculous answers to prayer have come in ways that not only tested my heart but also prepared me to steward the answer. I love to pray big prayers. I believe in a big God. But when He answers in small ways, I'm tempted to say, "Yes, Lord, I'm grateful. But . . . I didn't pray for *this*."

At that moment, I'm faced with two choices. I could celebrate the miracle and give thanks for this glimpse of glory, knowing this answer is packed with wisdom and provision. It's an opportunity to see the potential in small things. And it's a taste of things to come. I can be humbly grateful and *filled* with holy expectancy because God heard my cry!

Or I could look at the modest (or seemingly partial) answer, toss it aside, and shrug in frustration. I could choose to get offended or impatient and then decide to minimize the power of prayer. Which leads me then to doubt the goodness of God.

Just like with the Israelites, unbelief and entitlement are constantly nipping at our heels. We can either crush them under our feet as we raise our hands in gratitude, or we can wallow in self-pity that keeps our eyes on the ground.

I remember a time when I experienced a heartbreaking loss that felt so unjust it left me breathless. Yet within a couple of months, the Lord whispered in my ear that He would restore what was lost *and then some.* I knew I had heard from the Lord. Months and months passed without any sign or hint of a breakthrough. Some days, I was tempted to despair. Then, one day, the phone call came that pointed to a fulfillment of that promise.

Did I experience an instant restoration? No. In fact, the invitation was small, humbling, and a heartbreaking reminder of all I'd lost. But I remembered God's goodness. I allowed this small, new beginning to do a fresh, humbling work in me (clearly, I needed it). And I settled in for the long haul.

Over time, subtly yet miraculously, God opened the way for me and brought the restoration He'd promised. *And then some.*

We think we're ready for the full answer and the all-at-once break-through. But just as lottery winners are often worse off after the fact, our significant breakthroughs might crush us if given all at once.

God loves you with more passion and care than your body could ever contain. So often, we think our breakthroughs will fill the empty spaces in our souls. Yet to know His love *is* to be filled with the fullness of God (Ephesians 3:14–19).

As we trust God with the deep longings in our hearts, let us also trust the wisdom of His ways. Every season is the perfect season to better know His love. The more we trust His love, the more we will trust His ways. All His paths are wisdom and peace.

> As we trust God with the deep longings in our hearts, let us also trust the wisdom of His ways.

"My thoughts are nothing like your thoughts," says
 the LORD.
"And my ways are far beyond anything you could
 imagine."
Isaiah 55:8

I believe God is good!
He loves my faith and answers my prayers.
I trust the wisdom of His ways and the genius of His timing.
He makes me wait because He's making me ready.
Lord, awaken fresh faith in me!

*God makes me wait because He's making
me ready. I trust His timing.*

Isaiah 40:31; 2 Peter 3:8–9

day 30

Believe the Best; Hope for the Best

Loving Father, You're the source of goodness and grace, kindness, and truth. Fill my cup until it overflows. Heal the places in me that bend me toward suspicion. Strengthen the places in me that are prone to cynicism. While the love of most grows cold, I want to burn brightly for You! I want to believe the best about others because it honors You and nourishes me. I want to hope for the best always because I belong to You, and You deeply love me. I'm constantly and continually blessed because I live daily under Your provision. Thank You, Lord. Amen.

My husband is a commercial construction senior project manager. He oversees large-scale jobs like hospitals and sports stadiums. He lives under

constant pressure to meet budgets and schedules with ever-changing variables. It's a high-stress job.

He's got the perfect temperament for the work. I remember when our boys were young, and Kev was still new to the industry. He received a call on his two-way radio (those were a thing back then). The contractor screamed so loudly, I almost felt his spit coming through the radio. Kev listened calmly, answered his questions, and said he'd take care of it. Then he bent down, picked up our toddler son, and lovingly tossed him in the air until he giggled himself silly.

I stood, jaw dropped, and asked, "How are you not crying or at least not crabby after that verbal spewing?" He smiled sweetly, shrugged his shoulders, and said, "Well, at least he can't take away my birthday." I laughed out loud. He later explained the kind of pressure that man was under, and Kev wanted to do his best to alleviate some of his stress.

I've learned something from Kev as I've watched him over the years. First, he's no pushover. He has a backbone and stands up to bullies when he needs to. But he believes the best in others and generously offers the benefit of the doubt, not always because others deserve it but because that's the kind of man he wants to be. He says he travels lighter that way. And he does.

That posture doesn't come naturally to me. I sometimes joke that I have the spiritual gift of suspicion. I hate to admit it. But I've been stabbed in the back enough that trust doesn't come easily. Maybe that's the case for you as well. This is not to say we should blindly trust people who've betrayed us. God gives us wisdom in relationships for a reason. But cynicism and suspicion are different from the spiritual gift of discernment.

Remember in the Old Testament when Hannah ran to the temple and cried out to God for a baby? How did the priest Eli respond? He accused her of being drunk (1 Samuel 1:12–16)! Why was he so quick to believe the worst about this brokenhearted woman? Could it be because his own sons were perverting justice and getting drunk in the temple? It's quite possible that Eli viewed Hannah through the distorted lens of his unresolved pain.

We'll also wrongly read situations and judge innocent people as guilty until we allow God to bring healing and wholeness to our lives. How do we move from a lens of suspicion to one of grace and truth? We pay attention to the times we're tempted to believe the worst, connect our own dots, and draw wrong conclusions. Instead of waiting to see if our assumptions were correct, we ask God to do a deeper work of healing in our hearts.

Ultimately, everything is going to be all right. God is working *all* things together for our good and for His glory (Romans 8:28). He knows we're all a pile of contradictions, and He's at work purifying, healing, and restoring us in all the ways we need it. In the meantime, we can travel lighter by giving people the benefit of the doubt since everyone is fighting some kind of battle. By daring to believe the best, we give ourselves and others the grace we all desperately need. By hoping for the best, we give God the trust He so profoundly deserves.

> We can travel lighter by giving people the benefit of the doubt since everyone is fighting some kind of battle.

Trust in the LORD with all your heart;
 do not depend on your own understanding.

Seek his will in all you do,
 and he will show you which path to take.
Don't be impressed with your own wisdom.
 Instead, fear the LORD and turn away from evil.
Then you will have healing for your body
 and strength for your bones.
Proverbs 3:5-8

Because Jesus is alive in me,
I see what He sees!
I say what He would say.
I live as He lives.
And I give as He gives.

───

I believe for the best because God is ultimately in control.

───

Psalm 103:19; Proverbs 19:21

day 31

From Scarcity to Abundance

Faithful Father, You are loving, kind, and faithful. You provide, protect, and prepare me to steward all You have for me. Help me trust You more. Show me how I shrink back when You long for me to draw near. Heighten my awareness of how I grab for myself instead of trusting You to provide. All Your paths are peace, and all Your ways are good. I can rest in care and rely on Your love. You intend to destroy the works of the Enemy in my life until I can live free, whole, and abundantly. Thank You, Lord. Amen.

I grew up in a large family, and finances weren't abundantly available. We had food on the table and clothes on our backs. We were grateful. But the extras were hard to come by.

I specifically remember one day as a young girl, sitting at our breakfast table with a pen and a blank sheet of paper. My brother sat down across

from me and held a Twinkie like it was a bar of gold. I dropped my pen, stared at the delicious wonder of goodness, and asked him, "Where'd you get the Twinkie? Treats have been gone for two weeks." He knew he had me, so he held the treat closer to my face, turned it this way and that, and then pulled it back for a big, slow bite. I couldn't take my eyes off that Twinkie. At that moment, nothing mattered more.

My brother looked at me again, reached across the table, and said, "Here. You want it?" I love my brother, but we had a bantering relationship, and I didn't know whether he was about to trick me or he really meant to be kind. So, before we both knew what hit us, I reached for the Twinkie so fast that it exploded between my fingers. My brother looked shocked. He said, "I was about to give it to you."

Years later, I found myself in similar situations where I didn't know if God was tricking me or if He planned to be kind to me. So I grabbed for myself. I'd hear the soft whisper, *I was going to give you something so much better. You grabbed the Twinkie again.* As silly as it sounds, I knew exactly what God meant. My scarcity mindset betrayed my heart.

Nothing we can do for ourselves is better than what God can do for us. When we experience Him as the loving, caring Father He is, we can live with open hands, a generous heart, and an expectant posture. Anytime we grab for ourselves because we don't trust God, we miss out on wonder, awe, and an opportunity for growth.

Scarcity fuels self-preservation. We grab for ourselves because we fear there won't be enough, God won't come through for us, or the devil will

> *Nothing* we can do for ourselves is better than what God can do for us.

get away with stealing from us. These fears are understandable, especially if we've walked through painful seasons that God allowed. How are we to reconcile His goodness with our unmet longings?

This lesson has challenged me: self-preservation and kingdom life are incompatible. But I am learning. And the more I understand God's lavish love, the less I worry about seasons of lack. I finally know that in due time, those valleys will be filled.

If our hands are empty, God intends to fill them. If our hearts our broken, He wants to heal them. If our resources have dried up, we can count on God to provide what we need when we need it.

God's *no* and *not yet* are as kind as His *yes*. His abundant provision looks different in the varying seasons of life. His goal is never to spoil us; it's to transform us until we're like His Son, brimming with holy confidence and humble dependence, bursting with kingdom passion and Calvary love.

You may *want* an abundance of finances this season. But what if God wants to give you deeper contentment and a powerful prayer life? You may *long for* the right doors of opportunity to open. But what if God wants you to enjoy a season of intimacy so He can strengthen your sense of identity? You may want to be symptom-free today. But what if God is using the delay to grow your faith so you can see even greater mountains move in the future?

In every season, God has an abundance of something for you. And He is inviting you to move past *your* desires and move toward His divine desires for you.

Refuse to compartmentalize your faith. Look for the other areas of your life where He's generously provided for you, and let those serve as

examples of God's faithfulness. He's not holding out on you. He withholds no good thing from those who walk uprightly before Him.

> For the LORD God is our sun and our shield.
>> He gives us grace and glory.
> The LORD will withhold no good thing
>> from those who do what is right.
> O LORD of Heaven's Armies,
>> what joy for those who trust in you.
> Psalm 84:11-12

FAITH DECLARATION

I am abundantly blessed!
My heart is at rest.
God is generous and kind.
When I seek Him, I will find Him.

———

BRAIN RETRAIN

I am a child of God, and my Father is abundantly good.

———

FURTHER STUDY

Psalm 34:8; Romans 8:32

day 32

Pray Persistently

Gracious Father, thank You for inviting me to bring all my concerns to You! Thank You for delighting in every detail of my life. Show me, Lord, regarding some of the desires of my heart—have I given up too soon? Have I settled for less than You have for me? The closer I walk with You, the more intimately connected our desires are. Are there things You've intended for me that I've stopped contending for? Speak to my heart. Help me remember there is a purpose in Your provision. If You want me to believe You for something new, it's because there's a new facet of my calling I've yet to explore. I don't want to miss a thing. Ignite my prayer life until it blesses Your heart and makes You smile! In Jesus' name I pray, amen.

More than fifteen years ago, I walked through a dark night of the soul.[34] Certain things broke my heart, but it was more than that. I felt crushed

under the weight of spiritual oppression that seemed immovable. I'd lost my fire and my fight.

Kev appealed to me and said, "Why don't you go after this like you go after everything else? Where's your fight?"

Kev's words were all I needed to hear. I rose up, marched around my house, submitted my will to God, and then resisted the devil with fire in my bones (James 4:7). I immediately felt a shift in my perspective.

The more I prayed, the more I had to pray about. God reminded me of petitions I'd abandoned because I had been so demoralized by the spiritual battle. I brought those things to the forefront of my heart and mind and brought them before the Lord. Fresh vision and passion awakened within me. I knew some major breakthroughs were around the corner, so I prayed even more fervently—not in a striving way but an energized one.

Around that time, our pastor and his wife took us out to dinner. They leaned across the table and said, "Susie and Kev, we want you to go home and interview each other. Ask yourselves, 'What brings me rest, joy, and fulfillment?' And then rearrange your life accordingly. Don't wait until you're retired to figure those things out. Do it now."

The following day, we spent several hours earnestly praying and processing those questions. That led to some major life decisions. We moved, and we changed churches (because our pastor had just retired, and we felt called to another church we were connected to in our community). Looking back, I realize those changes were foundational in supporting our next phase of ministry. God ushered us into a new season of life.

In Luke 11, the disciples asked Jesus to teach them to pray. First, He taught them the Lord's Prayer. Then He unpacked another parable. In this

story, a man went to see a friend at an inconvenient time because he needed bread to feed his guests. The man told him to go away because he was already in bed. Read what Jesus said next.

"I tell you this—though he won't do it for friendship's sake, if you keep knocking long enough, he will get up and give you whatever you need because of your shameless persistence.

And so I tell you, keep on asking, and you will receive what you ask for. Keep on seeking, and you will find. Keep on knocking, and the door will be opened to you. For everyone who asks, receives. Everyone who seeks, finds. And to everyone who knocks, the door will be opened."

vv. 8-10

Have you lowered your expectancy of what God might do in your life? Have you settled into a place of passivity or written off the possibility of life change because it's not convenient right now? Or maybe you're under fire and feel backed into a corner by the intimidation and threats of the Enemy. No matter where life finds you today, know there's a God in heaven who *invites* you to ask, seek, knock, and persist in your requests.

Have you considered that God desires things for you that you haven't even pondered or imagined? It's time for a prayer awakening. You serve a mighty, faithful, generous, and good God.

> No matter where life finds you today, know there's a God in heaven who *invites* you to ask, seek, knock, and persist in your requests.

God's Word is alive.
His promises are for me.
I will pray in faith.
And I will live like I believe!

I pray about everything and trust God in all things.

2 Corinthians 1:20; Philippians 4:6–7

day 33

Jesus *Is* **Your Breakthrough**

Mighty God, You are the God of Angel Armies. You go before me and behind me. You sent Your beautiful Son to take my place on Calvary's cross so I could live in forever fellowship with You. You've withheld no good thing from me! I have everything because I have Jesus. He is my Defender and Deliverer, Fortress and Friend, Savior and Healer. He'll be with me until the end. As an heir of God and a joint heir with Christ, I am destined for a breakthrough! Help me live like it's true. I love You, Lord. Amen.

Over the years, I've had a recurring dream that served as a word picture for me. I was in this spacious, fenced-in field—like a large sheep pen, about a mile from end to end. I had plenty of space to move, but I wasn't free. I saw the mountains in the distance, but I never got to climb them or see them up close. Whenever I approached the gate, all hell broke loose. Howling

winds, swirling sand, and growling animals made it impossible to pass through the gate. I'd turn around and head the other way.

Eventually, I realized how clearly this dream depicted my health journey. Whenever I'd come close to a breakthrough, all hell broke loose, pushing me back to a less threatening place. In myself, I wasn't enough to break through the gate.

One day, I stumbled upon this passage of Scripture, which leaped off the page and into my heart.

> This is what the LORD says:
> "I will go before you, Cyrus,
> and level the mountains.
> I will smash down gates of bronze
> and cut through bars of iron.
> And I will give you treasures hidden in the darkness—
> secret riches.
> I will do this so you may know that I am the LORD,
> the God of Israel, the one who calls you by name."
> Isaiah 45:2-3

In this passage, the Lord was speaking to Cyrus, whom He used to deliver His people out of Babylon. But the Word is living, active, and powerful (Hebrews 4:12), and sometimes God highlights a passage to show us that *just as He is for us, the Word of God is for us.* He's the same yesterday, today, and forever (Hebrews 13:8).

When it comes to our faith journey, we can do plenty of things to

minimize the Enemy's access and maximize our joy and strength. But there are some things we cannot do for ourselves. And that shouldn't shake us. Why? Because we have Jesus.

Here's another passage that speaks of God's role in breaking through.

> The breaker [the Messiah, who opens the way] shall
> go up before them [liberating them].
> They will break out, pass through the gate and
> go out;
> So their King goes on before them,
> The LORD at their head.
> Micah 2:13 AMP

Too often, we fixate on our desired outcomes and miss the bigger story God is writing because of our faith. When Jesus hung on that cross, His blood spilled to the ground, causing the earth to tremble. He gave up His Spirit, and the world shook. The sky went dark. The temple curtain tore in two. Jesus' death was an earthshaking, miraculous moment—and your most significant breakthrough! Our Savior offered you intimate access to His Father's throne room. He gave you the right to join the royal family. He deposited His Spirit within you for present power and a promised future inheritance.

Your story *will* have a glorious ending. Your battles will serve a purpose. Your breakthroughs are divinely timed and orchestrated by God

> Jesus' death was an earthshaking, miraculous moment—and your most significant breakthrough!

Himself. If you're stuck and need a breakthrough, stand at the gate with firm faith and open hands, and call on the One who can level the mountains, cut through the gates, and set you free. He goes before you and will always make a way for you.

FAITH DECLARATION

Jesus is alive!
Jesus fights for me.
Jesus makes a way,
so I can walk free.

BRAIN RETRAIN

It is for freedom57 that Christ has set me free.[35]

FURTHER STUDY

John 8:36; 2 Corinthians 3:17

day 34

How Freely Do You Receive?

Gracious Father, keep me engaged in Your story! Show me how I limit You by my small thinking, unbelief, and assumptions. You're so much better than I know. You're kinder than I can fathom and more generous than I imagine. Expose the mindsets that have put You in a box and kept me from the best of what You have for me. You've freely given me more than I can appropriate in a lifetime. Help me receive freely all You have for me. Increase my capacity to accept Your goodness and rely on Your love. Amen.

———————

In John 5:6, Jesus asked a man who'd been sick a long time an unusual question: "Would you like to get well?" Jesus never wasted words. And He asked questions for our benefit, not His. He knows the answer to every question because He is the answer to every question. This poor man had experienced so many setbacks that his helplessness was baked in. His first words to Jesus were, "I can't, sir" (v. 7).

I write about this in my book *Fully Alive*,[36] but it bears repeating here. During the worst phase of my symptoms, the Lord repeatedly brought me back to that story in John 5. And quite honestly, it hurt my feelings. From my perspective, I couldn't have done more to position myself for healing. I stood on God's Word. Prayed the Scriptures. Took my supplements. Stayed away from bad food. Went to bed on time. Followed doctors' orders. It was clear to everyone around me I wanted to be well!

Still, God doesn't waste words. He asks questions to show us what we cannot see. So I asked the Lord, "Do I have some 'I can'ts' buried in my soul? Show me if there are obstacles within me."

A few days later, I stood backstage, about to step out to speak, and surges of numbness and dizziness disoriented and disappointed me. "No, Lord! Not here. Not now." I was fighting to get my bearings straight when the host grabbed my sleeve and said, "Hey, Susie. Make sure you tell them about all your health challenges. Otherwise, they're going to hate you when they get a look at you. You're such a cute little thing." At that moment, I recalled the many times I'd heard that very thing. "I'd hate you if you didn't struggle like you do."

God thundered in my heart, *If I heal you and people hate you, am I enough for you? Will you trust Me more than others' opinions?* It sounds crazy, but I had to disentangle from the fear that some might reject me when I'm healed.

Days later, while praying for human trafficking victims, the phrase *blessing guilt* passed through my mind. The Lord whispered, *Can you trust Me to heal you even while many suffer in the sex trade?* I didn't have to think

about it. I said, "No. I can't bear it." Theologically, I know that what God does for one doesn't limit Him from helping another. But when it came down to it, I didn't want Him to heal me while others suffered in such horrific ways.

You can imagine the conflict in my soul. I fasted. Prayed the Scriptures. I did everything I physically could to acquire a healthy body. But deep in my soul, I believed I shouldn't get healed; I couldn't get healed while others suffered. Yet God's resources are inexhaustible. I had some things to work out with the Lord. Perhaps you do as well.

How well do you receive all God so lovingly wants to give? Are you open to the possibility that some of the obstacles may exist in your own heart? One of the ways to know whether your theology is misguided is if you can finish this statement: "I'm not worth . . ." Not worth rescuing? Healing? Delivering? Providing for? Marrying? Forgiving? Promoting? Restoring?

None of us is worthy. But—because of Jesus—we're all *worth it*.

Start here. Picture Jesus standing before you with a smile that goes up to His eyes. He gently grabs your shoulders and asks, "What do you want Me to do for you?"

How would you answer? Ask your Father to increase your capacity to receive all He so lovingly wants to give you. May you learn to live like an heir. There's *so* much more that God has for you and *so* much more He wants to do through you!

> None of us is worthy. But—because of Jesus—we're all *worth it*.

"Up to this time you have not asked a [single] thing in My Name [as presenting all that I Am]; but now ask *and* keep on asking and you will receive, so that your joy (gladness, delight) may be full *and* complete."

John 16:24 AMPC

FAITH DECLARATION

Jesus is generous and kind.
I receive His love.
I believe in His promises.
I open my hands and live with holy expectancy.

BRAIN RETRAIN

I'm learning to receive everything my
loving Father has for me.

FURTHER STUDY

Luke 6:38-40; Philippians 4:19-20

day 35

Someone Stronger

Lord God Almighty, there is no one greater than You! No one is stronger than You! You are unrivaled, matchless, and unexplainable. You merely spoke, and the heavens were born. At the blast of Your breath, the bottom of the ocean can be seen. The earth trembles in Your presence, and the trees clap their hands.[37] All creation groans for the day when You reveal who Your children are to a waiting and watching world.[38] No one can snatch me from Your hand. I'm safe and secure in You. Thank You, Lord. Amen.

I was born with a strong sense of justice and a heart for the underdog. Even as a child, when I saw a bully beating up on someone, I'd jump in the middle and pull the vulnerable one to safety. My mom tells me—and I'm not proud of this—that I often walloped the bad guy before I walked away.

I remember a time in elementary school when kids relentlessly teased a

girl in my class. She was socially awkward and drooled when she nervously smiled. One day, I'd had enough. I stood up from my desk, stomped my foot, and yelled at those who were so petty. Then I pointed to the teacher and told her she should do a better job of sticking up for those who couldn't defend themselves. I didn't get in trouble for that one. In fact, my teacher told my mom she should be proud of me.

But then, one day, on the way home from school, some teen boys from another neighborhood jumped me and beat me up. They punched and kicked and laughed wildly as they did. I screamed and cried, and through my tears, I saw one of the boys I'd once defended standing a ways away, watching the whole thing. He looked terrified. I didn't blame him for not coming to my rescue. These boys were bigger and stronger than anyone my age.

They say that bullies aren't brave. They're only intimidating until someone braver and stronger stands up to them. Nobody stood up to the world's bullies better and more consistently than Jesus.

One day, He cast out a demon from a man who couldn't speak. When the demon left, the man put sentences together! Imagine. The crowds were amazed, but some accused *Jesus* of having a demon. Jesus explained that a kingdom divided against itself cannot stand. He didn't back down. He doubled down.

Then He said something I want us to catch:

"But if I am casting out demons by the power of God, then the Kingdom of God has arrived among you. For when a strong man is fully armed and guards his palace, his possessions are

safe—until someone even stronger attacks and overpowers him, strips him of his weapons, and carries off his belongings."
Luke 11:20-22, emphasis added

You and I are no match for our Enemy. And he often confronts us when we're at our weakest. But when we call out to God, our cry reaches His ears. He moves heaven and earth to help, rescue, and put us in a spacious place (Psalm 18:19). As we heal, He strengthens, teaches, and trains us, and He sets us on high places.[39] Jesus soundly defeated our Enemy. He has overwhelmingly set us up to win our battles.

Who or what are your bullies? Fear? Intimidation? Critical people? Those are some of the Enemy's favorite weapons. What if the next time you felt pressed by negativity in *any* form, you decided to count on God's goodness and strength and not be moved? What if you took authority over the devil's intimidation, put a flag in the ground, and declared, "If my God is for me, who can stand against me?[40] My God will come through for me!"

Even though lawlessness increases, you don't have to live in fear. Why? Because someone stronger has come, and He came for *you*. Now you can live under the shelter of His wings. His faithful promises are your armor and protection (Psalm 91:1–4). His Spirit guards and guides you on the best path for your life. His presence gives you peace.

You don't have to live in fear. Why? Because someone stronger has come, and He came for you.

You have all the heavenly resources necessary to move from victim to victor. You have a place to go with your fears when you're under fire. Yes, the Enemy is strong. But Jesus is far

stronger, and He is alive in us! Give thanks to the Lord, for He is good. And praise His name because He's also invincible and faithful (Isaiah 12:4–5)!

My children, you have come from God and have conquered these spirits because the One who lives within you is greater than the one in this world.
1 John 4:4 The Voice

FAITH DECLARATION

God is strong and mighty!
I am His child, and He loves me.
I am safe in His care.
He delivers and defends me!

BRAIN RETRAIN

No one is stronger than my God.

FURTHER STUDY

1 Chronicles 29:11; Psalm 33:6

day 36

Remember Your Good Memories

Faithful Father, I have such a legacy with You! Even before I knew You, You were intimately involved with me. You created me for Your glory. Continue to write a beautiful story with my life. Bring healing to the painful parts of my story. Flood my mind with my best memories. Help me see them in Technicolor. Use my good memories to help me heal so I might have even greater hope for my future. You've been good. You're good even now. And You'll always be good. Thank You, Lord. Amen.

Good memories are nourishment to your brain like a good salad is nourishment to your body. It's not enough just to have good memories. We need to bring them to the forefront of our minds, remember them, enjoy them, and thank God for every nuanced way those memories mean something to us.

The Enemy consistently goes after our thoughts because our battles are

won and lost in the mind. If he can sabotage our thoughts, he can disrupt our lives in ways we don't even realize.

Picture your life as a storybook. Now picture the loose pages stacked on top of one another with space between each page. Now imagine a heavy weight pushing down on the pages until they're entirely compressed on the ground. That's what trauma does to our story. It compresses the pages of our lives so we can no longer access our good memories. And you need your good memories to help you heal.

Those who've endured a series of unrelenting crises may look back over their lives and lament that they have no good memories. But when they ask God to help them remember, a good memory often surfaces. When they spend time with that memory in light of God's goodness, part of them starts to heal.

If the Enemy can compress your story to such a degree that you don't remember the ways God provided for you, he'll so distort your narrative that it'll be almost impossible to believe God for a healthy, healed future. I can personally testify to this.

In the middle of the worst parts of my health battle, a counselor friend challenged me to find one good memory. Surely I had more than one! I have a precious family and good friends. But I felt so pressed by the weight of the illness, all I could think of was how long I'd battled. Even so, I dared to ask God to show me a memory that would help me heal. And He did.

Right smack-dab in the middle of a long stretch of sickness and scary symptoms, I woke up one day and felt great. I didn't know what hit me. I decided to hop on my bike and ride as hard and fast as possible. My legs felt unusually strong. My sweat dripped in my eyes, which made me giddy

because I love the heat. The scents of summer awakened fresh life in me. After my ride, I floated in the lake, and the cool water felt like a healing balm. It was one of the best moments of my life.

I allowed myself to remember the heat of the day, the sweat dripping in my eyes, the taste of my electrolyte drink as I rode, and the healing feel of the cool lake water. This memory represented so much of what I'd lost. As I sat with each aspect of this part of my story and sincerely thanked God for it, joy fluttered within me. Genuine gratitude is the soil for hope. The Lord whispered, *I gave you this day as a glimpse of things to come. I will restore you.*

I'd return to that memory on my struggling days and thank God for His goodness. It was nourishment to my whole being. What I needed more than a healthy body was a heart that dared to trust God's goodness.

In due time, other beautiful memories surfaced. The truth was, they were there in my story. But until I asked God to redeem my memories, they were too compressed for me to access them. But praise God, my story was starting to breathe again.

Let's return to the picture of your story written on stacked pages, one on top of the other but with space between each one. The goal is to be so healed that you can access the different pages in your book—even the complex parts of your story—with a sense of wholeness and health.

Start a memory journal. And make sure to take pictures of the everyday moments that will make you smile later. Ask God to help you remember one memory that will help you heal. Consider your five senses and take time to remember things in detail. What did you see, smell, taste, touch, or hear? How did it make you feel? How might it serve as a word picture for how God wants to restore you?

One of the ways we come to truly rely on God's goodness is to remember that He's been good. When we can clearly recall our history with God, we'll more confidently trust Him with our future.

I remember the days of old.
I ponder all your great works
and think about what you have done.
Psalm 143:5

FAITH DECLARATION

God is writing my story for His glory!
He's been good, and He'll be good again.
I trust Him with my heart; I remember all His deeds.
I am blessed, and I can rest
because He is good and always will be.

BRAIN RETRAIN

God is healing and redeeming my memories.

FURTHER STUDY

Psalm 23:6; Psalm 107:2

day 37

Divine Revelation

Precious Father, thank You for Your great love for me. What an honor to be Your child. What an unfathomable privilege to hear Your voice. I have access to the God of all creation! And You don't merely tolerate me; You love me and desire fellowship with great affection and intention. Your heart aches when I look to lesser sources to satisfy the desires only You were meant to fill. Reveal to me Your heart. Tell me things I do not know. Awaken me to fresh wonder. I long to live in ever-increasing awe of You. Show me Your glory, Lord. Amen.

The One who spoke the galaxies into existence wants you to know Him, not as you perceive Him to be but *as He is*. His thoughts toward you outnumber the grains of sand on the seashore (Psalm 139:17–18). And every thought—not just some of His thoughts but *every* thought—toward you is redemptive, holy, and life-giving. Even His discipline and correction come

from His fatherly heart of affection, wisdom, and care. He's never petty, gossipy, or impatient. He's not two-faced or manipulative. He is God. He is good. And He loves you.

The more you understand His majesty, power, and authority, the more You'll trust that His ways are far superior to man's. We're not at the mercy of mere men. We're in the mercies of God! Scripture says that God *confides* in those who fear Him.

> The secret [of the wise counsel] of the LORD is for
> those who fear Him,
> And He will let them know His covenant *and* reveal
> to them [through His word] its [deep, inner]
> meaning.
> Psalm 25:14 AMP

Imagine walking in such reverence before the Lord that He entrusts some of His secrets to you! Yet He does this every day with His children. That's why Scripture says that the fear of God is just the *beginning* of wisdom (Proverbs 9:10).

Though these ideas sound lofty and reserved only for a few, they're promises offered to all of God's children. The more we understand what we possess in Christ, the more we'll learn to rely on the strength of our relationship and covenant with Him. His wisdom and revelation bring clarity to our lives.

I remember when one of our sons was in a relationship that seemed to sap the energy out of him. Yet he insisted he was okay. We asked God for

wisdom and revelation, and He gave it. We instantly knew what to say (and not to say). We came into a place of peace and rest and watched God work out His purposes for our son.

Though we all have plenty of examples of God's intervention, allow me to share another. I've mentioned the tough health stretch I've just come through. At one point, I realized I was working harder to be healthy than I believed God was working on my behalf. How did I know? The lack of peace and the presence of exhaustion. I prayed. "Lord?" That was it. And He whispered to my heart, *Susie, you acquire a healthy life by stewardship. You possess a healed life by faith. It's important to steward your health. But the kind of healing you need, you can't strive enough to obtain. Stop striving and trust Me as your healer.* That was a game-changing moment for me.

Some of the ways you know you've heard from the Lord are these: His insight surprises you. It's not something you'd have thought of yourself. His wisdom brings revelation and understanding where you didn't have it before. God's insights will never conflict with or contradict His Word. The more we spend time in God's Word, the more consistently we'll discern His voice.

He's brilliant. His revelation brings peace—even when He corrects us. When God imparts truth to us, we're reminded that we're His. We can count on Him. And hope arises.

Everyone needs healing, refreshment, and restoration. We all need discernment, direction, and protection. God has storehouses of answers, insights, and wisdom available to us. May we continually ask our generous Father for His wisdom and revelation (James 1:5).

Did you know that the Israelites broke God's heart by their refusal

to ask for His input or seek His guidance? He *wants* to be involved in your life! Seek Him while you can find Him. Call on Him while He's near (Isaiah 55:6). Oh, the wisdom and understanding He has for you!

> God has storehouses of answers, insights, and wisdom available to us.

For the LORD gives [skillful and godly] wisdom;
From His mouth come knowledge and understanding.
He stores away sound wisdom for the righteous
 [those who are in right standing with Him];
He is a shield to those who walk in integrity [those of
 honorable character and moral courage].
Proverbs 2:6-7 AMP

FAITH DECLARATION

*The God of all creation
loves me and speaks to me.
I will bend my ear and listen for His voice.
My soul waits for Him!*

BRAIN RETRAIN

Daily God speaks. Daily I listen expectantly.

Psalm 5:1-8; John 16:13

MY RESPONSE

day 38

God Is Willing

Faithful Father, I'm learning to trust You and wholeheartedly believe that You are good, kind, and faithful. I refuse to waver in unbelief regarding the promises of God. Though the storms rage, I stand on the truth. I know You intend to transform me from the inside out. You've purposed to use me in ways I cannot imagine. And You've made promises to me based on Your perfection, not mine. Help me stand firmly on the truth of Your Word and pray bold and beautiful prayers from there! Amen.

Many years ago, I did a series of radio interviews for a book I'd just released. One day, I stepped into a radio studio in Chicago. I felt an instant connection with the host. She reached between the monitors, squeezed my arm, and told me she was glad to have me as her guest. We went live and had a

great back-and-forth conversation. I watched her work with great interest. She spoke with me while cueing her producer. Something quickened within me.

I'm an introvert. I love deep, one-on-one conversations. I like the energy and pressure of live radio. I enjoy my fellowship with God, so I paid attention to the flicker of life I felt. I asked God about it. I sensed His invitation to pay attention to this budding desire within me.

From then on, whenever I was in a studio for an interview, I felt an overwhelming desire to work in radio. I asked the Lord, "Father, if this is a selfish desire, take it away. If it's from You, grow it within me and then move the mountains before me!"

One day, I walked out of our local Christian station after an interview. The producer caught up to me as I approached my car. She asked if I'd consider training to be their backup guest host. That was almost twenty years ago!

I served as a guest host for four years before the door opened for me to have my own radio show. Many people cautioned me against it; they said it was a bad idea. They figured that if I spent my time behind the microphone interviewing other authors, I'd kill my own writing career. I considered their thoughts but was so buoyed up by peace that I had to walk through the door. I figured if God was done with me writing books, so be it. I had to cooperate with God's movement in my life.

God planted a seed of a desire within me and then watered it with His Word. At times it seemed He moved so painfully slow, but looking back, I'm in awe of His timing, goodness, and attention to detail. It turns out that reading books every day to interview authors every day has made me

a better writer. I didn't stop writing books. God continued to bring revelation in ever-increasing measures.

All of that is to say that God wants to work through you more than you want Him to work through you. And He can multiply your offerings in ways you can't even imagine.

He plants specific desires in our hearts that He doesn't want us to ignore. If you step into a new situation and something comes alive in you, pay attention. If you feel at home in an unfamiliar setting, make a note of it. God may be birthing something new in you. What's glorious is how uniquely He's made each of us. What stirs up faith and excitement in you is likely different from what does for me. But we are His image bearers, and that's the beauty of being part of the body of Christ (Genesis 1:27).

> God wants to work through you more than you want Him to work through you.

We don't have to wonder if God wants to work wonderfully and beautifully through us. We don't have to wonder if God wants us to flourish in His presence. We don't have to wonder if God wants to do a new thing in us. We can know that He does, and He is! He has given us clear insight into His character and heart's desires. He's made that perfectly clear in His Word.

> We are sure that if we ask for anything He wants us to have, He will hear us. If we are sure He hears us when we ask, we can be sure He will give us what we ask for.
>
> 1 John 5:14-15 NLV

God is working in you, giving you the desire and the power to do what pleases him.
Philippians 2:13

Maybe you've been so battered by life you've lost sight of some of the things that are yours because you belong to Jesus. Know this: He's more than willing and able to do the miraculous in your life. Yes, there's a mystery to His ways and timing, but don't let the perceived delays dim your view of who He is. He is mighty to save and has set His affections upon you (Zephaniah 3:17).

FAITH DECLARATION

Because of Jesus,
I am bold, beloved, and brave.
I know God, and He knows me!
He works mightily in and through me.
He will fulfill His purposes for me.

———

BRAIN RETRAIN

God wants to do great and beautiful
things in and through me.

———

Ecclesiastes 3:11; 1 Corinthians 1:27

MY RESPONSE

day 39

Seek His Blessing

Loving Father, oh, that You'd bless me indeed! Expand Your territory in me—increase my capacity for You. Increase Your territory around me—do more in and all around me! May Your hand of power and goodness rest upon me. Keep me from evil and harm.[41] *Help me be so in tune with Your Spirit that I'm always in the right place at the right time because You order my steps. You love to be good to us. Help me live a life that honors and blesses You, Lord. Amen.*

———

Your Father *wants* to bless you. He longs to be gracious to you. He has storehouses of blessings and answers to prayer waiting for you.

We often lose our sense of wonder and expectancy after prolonged suffering or hardship. It's hard to reconcile God's goodness with what He allows to happen. And therein lies the mystery of walking intimately with God on a fallen planet with hurting people. But may we never forget that *what He allows, He redeems.*

For example, I cannot count how many days in the past thirty-plus years I've felt crummy more often than not—there are too many. What has redemption looked like for me? The pressure of daily illness has compelled me to grab hold of God's Word more fiercely than I would have. I know God. I love His Word. And because He's near to the brokenhearted (Psalm 34:18), I've experienced His nearness in a way that has profoundly changed my life. His presence is everything.[42] Honestly? From where I stand now, I don't feel I've lost anything. I've gained so much in Christ that I feel rich in every way. And the more I've immersed myself in God's promises, the more ground I've gained in my healing process. Even though I deal with daily symptoms, I'm more healed now than I've ever been. Praise God!

The Father doesn't want us to lose heart. He wants us to stay brave. To be kind. And to contend for His kingdom to come to earth as it is in heaven (Matthew 6:10). The Enemy of our souls wins if we lose our expectancy. Keep your heart engaged with the purposes of God. Count on the goodness of God. It'll keep hope alive!

> The LORD waits [expectantly] *and* longs to be
> gracious to you,
> And therefore He waits on high to have compassion
> on you.
> For the LORD is a God of justice;
> Blessed (happy, fortunate) are all those who long for
> Him [since He will never fail them].
> Isaiah 30:18 AMP

In 1 Chronicles 4, we read about the descendants of Judah. The first eight verses list the names in the family line. But then the genealogy pauses on verse 9. Why? Because someone dared to see beyond his limitations and seek God's blessing. His name was Jabez, and he was born through pain. His name *means* pain. Imagine hearing the word *pain* every time your mom called you for dinner. Yet Jabez dared to appeal to God in His goodness and ask for more. And God answered his prayers.

Bruce H. Wilkinson wrote an excellent book about the prayer of Jabez that is totally worth the read. He wrote:

> Most of us think our lives are too full already. But when, in faith, you start to pray for more ministry, amazing things occur. As your opportunities expand, your ability and resources supernaturally increase, too. Right away you'll sense the pleasure God feels in your request and His urgency to accomplish great things through you.[43]

People are hesitant to ask for a blessing because it feels like a selfish thing to do. But if we truly engage our heart with God's heart, He shapes our desires, heals our hurts, and corrects us in our wayward ways. He wants us to engage with Him.

What if you boldly dared to ask God to bless you, use you, and surprise you? And then you decided to press in more, read His Word, and give Him permission to shape your desires? I dare you.

What if you boldly dared to ask God to bless you, use you, and surprise you?

Oh, that You'd bless me indeed!
That You'd increase my territory!
That Your mighty hand of power would rest upon me!
And that You'd change the world through me!

God wants me to seek His blessing.

Psalm 37:4; Matthew 6:33

day 40

Any Day Now

Everlasting Father, You've set eternity in my heart.[44] *Now awaken fresh faith in me. Help me to live perpetually sensitive to Your Spirit, fully expectant that I'll see You move. You've empowered and equipped me to live an eternally significant life. My faith matters. You're preparing a place for me.*[45] *May I live each day with holy anticipation. I look forward to seeing You face-to-face when, at last, I'll be home. But for now, I'm waiting, watching, and listening, ready to move at the sound of Your voice. Come, Lord Jesus, come! Amen.*

Do you believe that you will see God move *any day now*? That He has taken to heart your prayers and is so committed to His purposes for you that He's working at this moment? I'm so excited to see the miraculous things He has up His sovereign sleeve!

Living with holy expectancy and counting on God's involvement is faith in action. It's nourishment for the soul. Those who eagerly look forward to something good experience higher rates of happiness and a higher capacity to notice goodness when it comes. We, as believers, have the highest and best reasons to live with joyful expectancy. Heaven awaits us! God is with us. And even now, He's answering our prayers.

In Scripture, we read plenty about saints who cultivated such a listening lifestyle that they orchestrated their lives around the voice of God. In Luke 2, we meet Simeon, who was righteous and devout, and he eagerly awaited the Messiah. The Holy Spirit was upon Simeon and assured him he would not die until he saw the Messiah. He waited on God. And then, *one day*, the Spirit led him to the temple (vv. 25–32).

Simeon found a young couple with a little baby. He'd lived so close to the Lord that he recognized the Messiah as an infant. Conversely, the religious leaders who were experts in the law would miss Jesus entirely, even though He healed people before their very eyes. And don't forget about the prophetess Anna (Luke 2:36–38). She lived continually engaged with the presence of God through fasting and prayer. She, too, recognized her King when He was only a baby in His mother's arms.

Later in Luke's gospel, we read about a man who responded to an inner prompting to prepare a room for something or someone special. It was common practice for Jews in Jerusalem to offer guest rooms to travelers. But I'm guessing he wondered who he was cleaning and organizing for. He made room for a gathering, trusting he'd know what to do next (22:7–13).

Jesus told His disciples to look for a man carrying a water pitcher and

follow him to his house. Jesus said the man would lead them upstairs to a large room *already* set up. This would be the place for the history-making Passover meal. All because an unnamed man responded to the nudge of the Holy Spirit.

All over the world, God is repositioning His *willing* saints, moving them into places to bring the breakthroughs the world so desperately needs.

In Muslim communities, Jesus regularly appears in dreams and shows these dear people that He is the Messiah and that He loves them. Most often, Jesus directs them to a believer in the right place at the right time to show them the way of the kingdom.[46]

Each day is packed with eternal possibilities. Even the Enemy's schemes against us hold the potential of a future reward. How? When we learn to leverage our trials to our advantage and use them to shore up our defenses, deepen our faith, and strengthen our trust in God. We'll learn to live with eternity in mind when we awaken to the idea that we're more spiritual than physical. Life on earth is short. Eternity is long. Our heavenly home is secure. And that's why God charges us to fix our eyes on what we cannot see. He wants us to live powerful, humble lives that He can richly reward—and that no enemy can destroy.

Yours is a beautiful life that will one day be so glorious it'll take your breath away. One of the most miraculous things about God is that He takes broken things and makes them beautiful. I can't wait to see all God has accomplished because you were a humble, repentant, faith-filled, willing vessel. It will be the stuff of miracles. I'll be in the crowd cheering for you! In the meantime, lean in, listen closely, and watch for Jesus.

So *get yourselves ready*, **prepare your minds to act**, control yourselves, and look forward in hope as you focus on the grace that comes when Jesus the Anointed *returns and* is completely revealed to you. Be like obedient children as you put aside the desires you used to pursue when you didn't know better. Since the One who called you is holy, be holy in all you do.

1 Peter 1:13-15 THE VOICE

FAITH DECLARATION

Life on earth is short.
Eternity is long.
Jesus is coming.
And I'm living ready!

BRAIN RETRAIN

As a child of God, I live each day with holy expectancy.

FURTHER STUDY

Luke 1:37; Galatians 2:20

conclusion

Learning to Live with Holy Expectancy

Here we are! We made it through our forty-day journey together. I pray God has used each day to lift your chin, shift your perspective, and prepare your heart for His beautiful involvement in your story. Life is so much better when we're aware of God's presence and assured of His goodness.

I'm praying that you've developed a practice of regular, sincere gratitude. Staying attuned to God's kindness is medicine for the soul and fuel for our faith. He's always good, and we honor Him by noticing and thanking Him for the countless ways He lavishes His love on us.

I'm praying, too, that you feel inspired to pray big prayers and dream big dreams. Your faith is precious to God, and He cares about every detail of your life. And remember, your life on earth is not just about your life on earth. Every step you take here echoes into eternity. Every bit of hope you reach for, love you offer, and faith you engage holds significance in heaven.

You are a masterpiece created by God Himself to do great and wonderful things He's prepared for you during your time on earth (Ephesians 2:10).

The more you learn to trust in God's goodness and believe that you are priceless, the more miraculous your life will become. You can trust Him. He's got you.

FAITH DECLARATION

May God Himself
heal, restore, and strengthen me fully.
May He awaken, encourage, and equip me abundantly.
May I live such a miraculous life
that many see and hear and put their
trust in the Lord our God!
Amen.

BRAIN RETRAIN

My new beginning starts today.
I choose to believe that God is good.
I can rest while God works.
I am practicing hope today.
God is doing something new in me.
I am securely tethered to God, and I trust Him.
I dare to dream new dreams.
I reject rejection and accept acceptance.

I am fearfully and wonderfully made.
I am who God says I am.
I choose life. I speak life.
God empowers my words and fuels my faith.
I am growing in resilience.
I walk in God's presence as I live here on earth.
Because God is faithful, I will keep walking and
keep believing.
I will not die but live and declare the works of
the Lord.
I love my body. It's a gift from God.
I'm destined for wholeness and freedom.
By God's grace, I am healing. I am being restored.
Goodness is on its way to me.
God is my refuge and my safest place.
I live victoriously in the epic story God is writing
in my life.
My Good Shepherd leads, and I follow.
God guards and guides me, even at night.
My valleys will be filled with pools of blessing.
By God's grace, He's restoring my soul and
making me whole.
I dream big because I serve a big God.
By God's grace, I will shine ever brighter until the
end of time.

God makes me wait because He's making me ready. I trust His timing.

I believe for the best because God is ultimately in control.

I am a child of God, and my Father is abundantly good.

I pray about everything and trust God in all things.

It is for freedom that Christ has set me free.

I'm learning to receive everything my loving Father has for me.

No one is stronger than my God.

God is healing and redeeming my memories.

Daily God speaks. Daily I listen expectantly.

God wants to do great and beautiful things in and through me.

God wants me to seek His blessing.

As a child of God, I live each day with holy expectancy.

acknowledgments

Though my name is on the cover of this book, I could not have finished this project without the help of friends, family, and colleagues.

Kyle Olund, I'm so grateful to serve with you. You're an amazing man of God, an insightful friend, and a wise acquisitions editor.

To Damon Reiss, Caren Wolfe, Brooke Hill, Ashley Reed, Allison Carter, Elizabeth Hawkins, and Madison Baird. I'm so honored to serve alongside you. Thanks for inviting me to be part of the W team. Thanks for all you've done to steward the words God has entrusted to me. Richest blessings to Jennifer McNeil and Jennifer Stair for your editorial work. Thank you for setting the bar high. You brought excellence to this message. Thank you!

Steve Laube, thank you for your faithfulness through the years.

To my Marvel Prayer Warrior Women: Esther, Karna, and Melissa. I met my match when I started praying with you. Your fierce, focused, passionate prayers and loving friendship have changed my life. I'm forever grateful.

To Lynn. Kev and I love and appreciate you more than we can ever express. Thank you for your constant and continual intercession. You're a trusted voice in our lives.

To the team at Faith Radio. What an honor it is to serve alongside you. Here's to many more faithful, fruitful years of service!

To our Rwandan family. You've shown us what kingdom life looks like. You inspire us, challenge us, and encourage us. May God continue to use you to change the world. We love and appreciate you so!

To our wild and wonderful extended family (Mom, siblings, in-laws, nephews, nieces). I cannot imagine life without you. I love you more than I can say. You're my happy place.

To my kids and all our grandbabies. You are my world! I love you to the moon and back. May all your dreams come true. May God's love feel more tangible with each passing day. And may He continue to use our family to help as many people as possible. I love that we have one another.

To Kev, my best thing. I don't want to make a move without you. I praise God for all He's done in and through us. May He continue to work wonders in and all around us. And may He continue to surprise us with His goodness.

To Jesus. My life is wrapped up in Yours. Thank You for saving, healing, and redeeming me in ways I never thought possible. I'm living expectant for Your soon return. Please breathe life into the words on these pages. Heal broken hearts. Set captives free. Bring prodigals home. And awaken us all to the wonder of Your great love. Amen.

notes

1. As quoted in Susie Larson, *Closer Than Your Next Breath: Where Is God When You Need Him Most?* (Nashville: W Publishing, 2023), 107.
2. Tibi Puiu, "How Long It Takes to Break a Habit, According to Science," ZME Science, May 7, 2023, https://www.zmescience.com/feature-post /health/mind-brain/how-long-it-takes-to-break-a-habit/.
3. Ruth Haley Barton, *Embracing Rhythms of Work and Rest: From Sabbath to Sabbatical and Back Again* (Downers Grove, IL: InterVarsity Press, 2022), 9–10.
4. Isaiah 43:19.
5. "What Happens to Your Body During the Fight-or-Flight Response?," Cleveland Clinic, December 9, 2019, https://health.clevelandclinic.org /what-happens-to-your-body-during-the-fight-or-flight-response/.
6. Susie Larson, *Fully Alive: Learning to Flourish—Mind, Body, & Spirit* (Bloomington, MN: Bethany House Publishers, 2018), 11.
7. Max Lucado, *Help Is Here: Finding Fresh Strength and Purpose in the Power of the Holy Spirit* (Nashville: Thomas Nelson, 2022), 35, 37.
8. Yes, the Enemy writes pain into our present story, but in the future, when our faith becomes sight, we will be able to shout from the mountaintops, "Our God is good! His plans for me are good. He has redeemed every part of my story!"
9. Psalm 139:18.
10. In this passage, God is speaking to Cyrus, but there's a valuable lesson for us here too. Ponder God's words to Cyrus, and ask God to show you whether

you've questioned His ways and wisdom with you. That's a great step toward healing.

11. Ephesians 2:6.

12. Interlinear Study Bible, Proverbs 18:21, StudyLight, accessed June 27, 2023, https://www.studylight.org/interlinear-study-bible/greek/proverbs/18-21.html.

13. Olga Khazan, "Relieve Your Anxiety by Singing It," *The Atlantic*, April 13, 2016, https://www.theatlantic.com/health/archive/2016/04/relieve-your-anxiety-by-singing-it/477960/.

14. For example, the word *meditate* can also read as *recite* in Joshua 1:8, and translates to *moan, growl, utter, mutter, speak*. See Interlinear Study Bible, Joshua 1:8, StudyLight, accessed June 27, 2023, https://www.studylight.org/interlinear-study-bible/hebrew/joshua/1-8.html.

15. Matthew 5:8.

16. Interlinear Study Bible, Joshua 3:5, StudyLight, accessed June 27, 2023, https://www.studylight.org/interlinear-study-bible/hebrew/joshua/3-5.html. (Other translations use the word "sanctify" rather than "consecrate.")

17. C. S. Lewis, *The Weight of Glory: And Other Addresses* (1949; repr., New York: HarperOne, 2009), 26.

18. Psalm 116:9.

19. True lament is biblical. We take our honest, hurting selves before a most holy God, and we process our pain in His presence. We learn to find perspective in light of His promised presence and glory. And we find peace on the healing journey.

20. Jim Daly with Paul Batura, "Canada Calls for 'Mercy Killings' of Children—Without Parental Consent," *Daly Focus* (blog), *Focus on the Family*, Februrary 20, 2023, https://jimdaly.focusonthefamily.com/canada-calls-for-mercy-killings-of-children-without-parental-consent/.

21. Suicide rates vary year to year and country to country. In the US, suicide was the eleventh leading cause of death in 2021. See National Center for Health

Statistics, "Suicide Mortality in the United States, 2001–2021," CDC, April 2023, https://www.cdc.gov/nchs/products/databriefs/db464.htm. For global suicide statistics, see "Suicide," World Health Organization, June 17, 2021, https://www.who.int/news-room/fact-sheets/detail/suicide.

22. Psalm 118:17.

23. Psalm 139:14.

24. Interlinear Study Bible, Jeremiah 29:11, StudyLight, accessed June 27, 2023, https://www.studylight.org/study-desk/interlinear.html?q1=Jeremiah%2029.

25. Romans 16:20.

26. Susie Larson, *Fully Alive: Learning to Flourish—Mind, Body, & Spirit* (Bloomington, MN: Bethany House Publishers, 2018), 41.

27. Phillip Keller, *The Shepherd Trilogy: A Shepherd Looks at the 23rd Psalm, A Shepherd Looks at the Good Shepherd, A Shepherd Looks at the Lamb of God* (1970; repr., Grand Rapids: Zondervan, 1996), 60.

28. Psalm 16:7.

29. Interlinear Study Bible, Psalm 16:7, StudyLight, accessed June 27, 2023, https://www.studylight.org/interlinear-study-bible/hebrew/psalms/16-7.html.

30. Psalm 84:6.

31. *Susie Larson Live*, podcast, https://myfaithradio.com/programs/susie-larson -live/. Search for interviews with Jeff Manion.

32. Terry A. Smith, *The Lord Bless You: A 28-Day Journey to Experience God's Extravagant Blessings* (Minneapolis: Chosen, 2023), 55.

33. Proverbs 4:18.

34. I wrote about this season in two of my books. I wrote about how I got my feisty faith back in *Your Powerful Prayers: Reaching the Heart of God with a Bold and Humble Faith* (Bloomington, MN: Bethany House, 2016), and I wrote about how I navigated the season when God seemed silent in *Closer Than Your Next Breath: Where Is God When You Need Him Most?* (Nashville: W Publishing, 2023).

35. Galatians 5:1.

36. Susie Larson, *Fully Alive: Learning to Flourish—Mind, Body, & Spirit* (Minneapolis: Bethany House, 2018), 11–12.

37. Psalm 104:32; Isaiah 55:12.

38. Romans 8:22–23.

39. Read Psalm 18 and make note of how, when we call on the Lord, He rescues us and then moves us from victim to victor.

40. Romans 8:31.

41. This is a paraphrase of the prayer of Jabez found in 1 Chronicles 4:10.

42. If you want to explore the wonder of God's presence, check out my book *Closer Than Your Next Breath: Where Is God When You Need Him Most?* (Nashville: W Publishing, 2023).

43. Bruce H. Wilkinson, *The Prayer of Jabez: Breaking Through to the Blessed Life*, anniversary ed. (2000; repr., Colorado Springs: Multnomah, 2005), 36.

44. Ecclesiastes 3:11.

45. John 14:2–4.

46. My friend Tom Doyle has amazing stories about this. Check out his organization, Uncharted Ministries, for more information. https://unchartedministries.com/about-us/.

about the author

SUSIE LARSON is a bestselling author, national speaker, and host of the popular radio show *Susie Larson Live*. Whether behind a desk or behind a mic, Susie lives out her passion to see people everywhere awakened to the depth of God's love, the value of their soul, and the height of their calling in Christ Jesus.

A two-time finalist for the prestigious John C. Maxwell Transformational Leadership Award, Susie is the author of over twenty books and devotionals, and her Daily Blessings reach over half a million people each week on social media. Her radio show is heard daily on the Faith Radio Network, as well as around the world through her podcast, which has more than 3.5 million downloads. A popular media guest and guest host, Susie has frequently appeared on shows like *Focus on the Family*, *Life Today*, and *Family Life Today*.

In addition to her work and ministry, Susie loves to laugh and relax with her family. She and her husband, Kevin, have been married since 1985. Together they have three wonderful (and hilarious) sons, three beautiful daughters-in-law, a growing bunch of delightful grandchildren, and one adorable pit bull named Memphis.

WAKING UP

to the

GOODNESS
OF GOD